# MASTERING
# FANTASY ART
## DRAWING DYNAMIC CHARACTERS

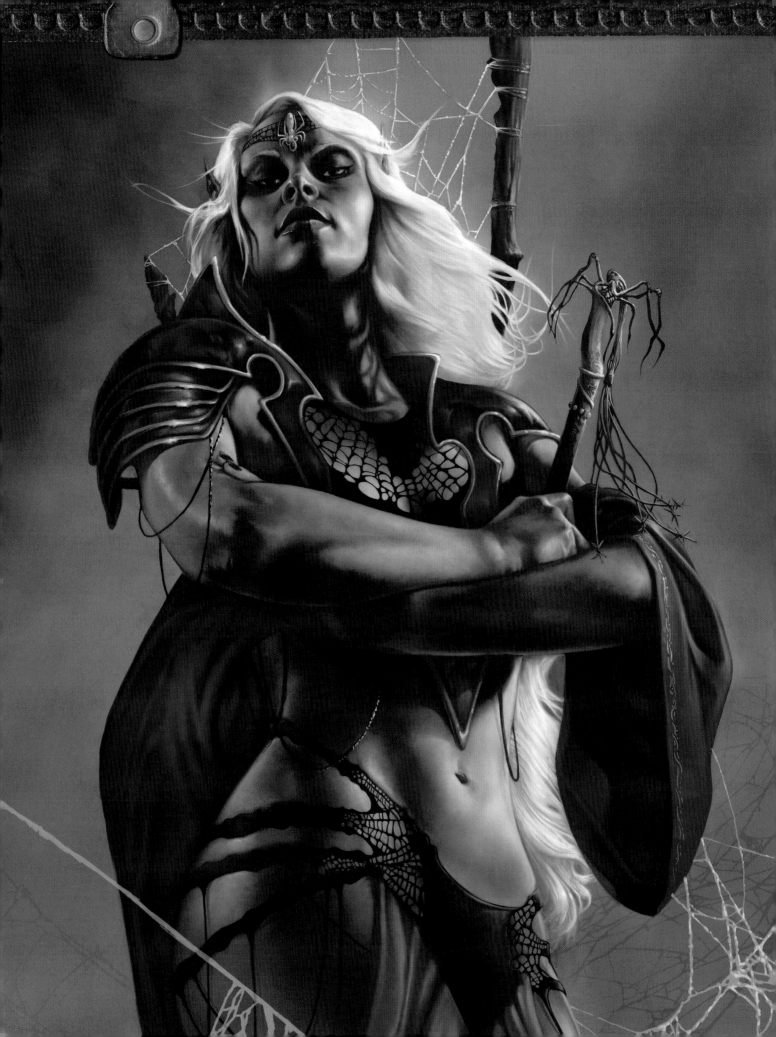

# MASTERING FANTASY ART
## DRAWING DYNAMIC CHARACTERS

### PEOPLE, POSES, CREATURES & MORE

**JOHN STANKO**

IMPACT
CINCINNATI, OHIO
impact-books.com

# CONTENTS

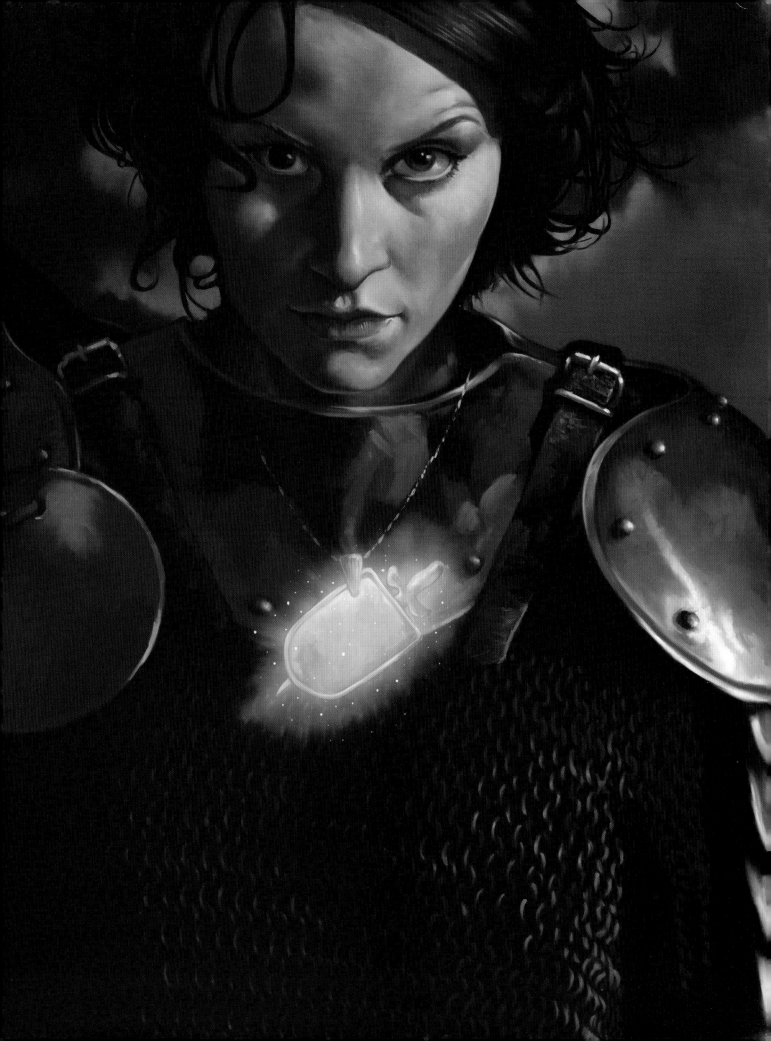

# INTRODUCTION

A few years back I went to a wonderful talk given by master fantasy and science fiction artist Todd Lockwood. During the talk, the importance of working with photo references came up, and he said something that has profoundly changed my approach to making art. He said, "We all know what our mom looks like, but we can't draw her." Take a few moments to think about this statement. For most of us, it's impossible to draw someone we see every day from memory. And if you can't draw someone you see every day, what about drawing things you don't see every day like horses or trains? As artists, we often assume we know more or less what a horse or train looks like enough to draw it from memory as best we can. Unfortunately, this leads to drawing what you *think* something should look like. Most of the time, this approach leads to widely inaccurate drawings and a set of problems that can be impossible to fix.

My purpose for creating this book is to share my process for creating dynamic characters. It has taken many years, and many failures, to refine my process to where it is now. For those who are new to fantasy art, I hope this book helps you create more successful art by avoiding many of the pitfalls and failures I had to learn the hard way. For those that are more seasoned, I hope this book offers some new, or old but forgotten, methods to add to your creative process.

—John Stanko

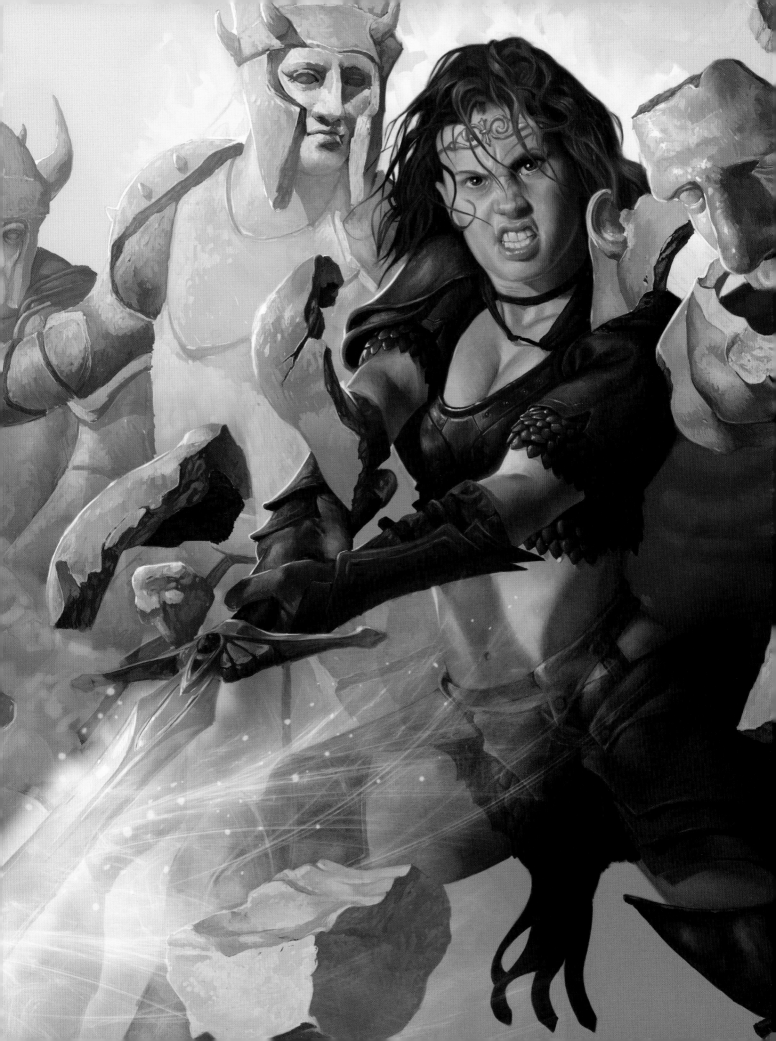

# GETTING STARTED

Many athletes will tell you that winning or losing is already decided before the first player ever steps onto the field. For an athlete to be successful on game day, they need to put in hours on practice field, conditioning, studying the opponent and more. It's the same when creating art. Often the success or failure of a drawing can be determined before the pencil ever touches the paper. This section will give you various strategies to help you start off your drawing the right way. By explaining the importance of photo references, what makes a good reference and how to work with a model, you will be well on your way to taking your art to the next level.

SPITEFUL SHADOWS © Wizards of the Coast

8

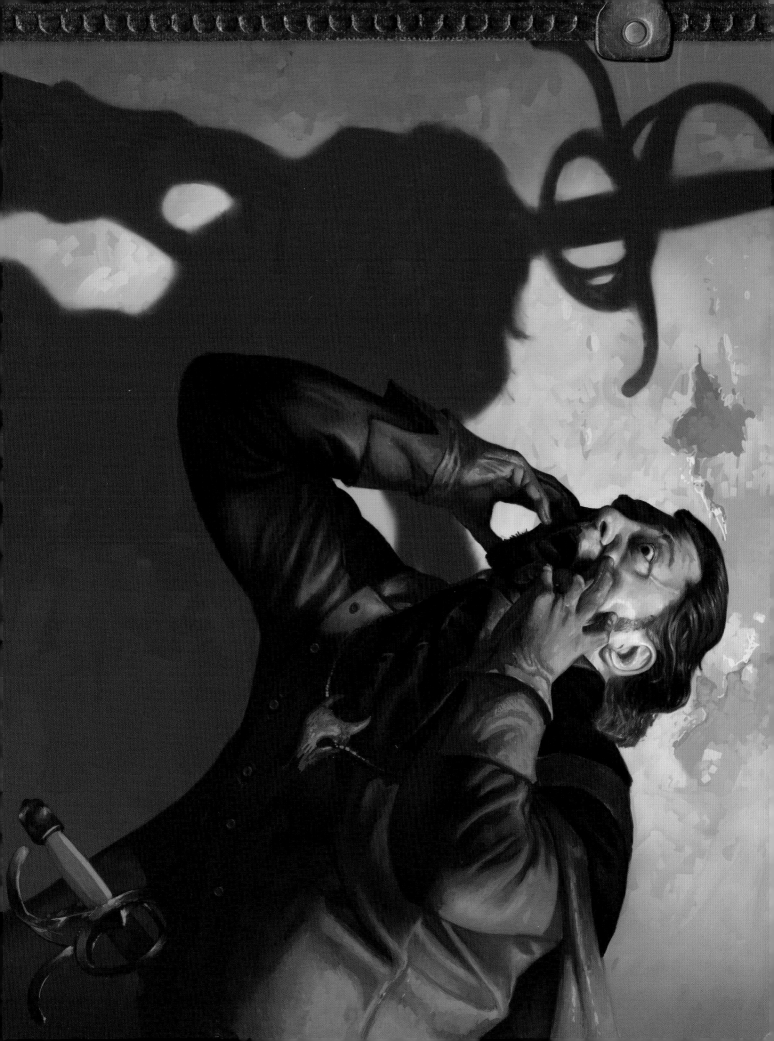

# THE IMPORTANCE OF USING REFERENCE PHOTOS

For artists, the human brain is extremely powerful though it's not perfect. It tends to record only the most important details for our long-term memory, then it removes any extra stuff deemed less important. This valuable process keeps us from getting overloaded with all of the sensory input we constantly receive. Unfortunately for an artist, this memory dump often includes valuable visual information. That's why the research phase of a drawing is equally, if not more, important than the time spent physically drawing. Having the right drawing reference can save hours and hours of time by allowing us to replace the information that our brains keep trying to erase.

Photo references help us identify and correct problems in our drawings much faster and much more accurately than a simple visual once-over. Everyone can look at a drawing and identify if

the nose is off or if the eyes just don't look right. Most of the time noticing errors is easy. Just look at any discussion board on how to draw, and you will find hundreds of people willing to point out every flaw in a drawing. The real value is figuring out how to correct the errors. For example, if you draw a face and the mouth looks off, how do you decide to change it? Should you move it up or down, make it smaller or larger, darken or lighten the values? If you are relying only on memory or drawing from your imagination, then you might as well just flip a coin and hope you get it right. However, by comparing your drawing to a reference, you can quickly decide if the top lip needs to be darker or the bottom lip needs to be larger.

Learning to draw takes time, practice and lots of hard work. Your biggest obstacle in learning to draw and becoming a better artist is always going to be you or more accurately your brain. Our artist brains are constantly fighting with what our eyes see. Just having a great reference to work from won't always guarantee a great drawing, but it will make it much easier to draw what you actually see.

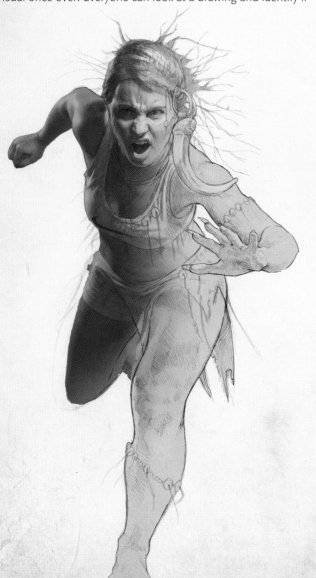

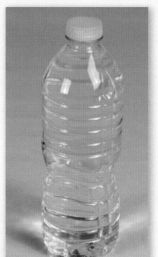

### Reference Captures the Little Details

Study this photo of a water bottle. At first glance you see the basic silhouette shape, the direction of the light and the general value of the lights and darks. If you close the book and picture the image in your mind, will you remember the details of the many bright white highlights?

### Research Is the Key to Accuracy

If you look at any human face, it has hundreds of different planes and contours, and light can affect each differently. Some of the planes have sharp changes while others are soft. Trying to mentally calculate how light affects these planes accurately is time consuming at the least, and at worst it can be nearly impossible. Having a variety of accurate reference photos of your models and props will always help you create more accurate, interesting and unique characters and drawings.

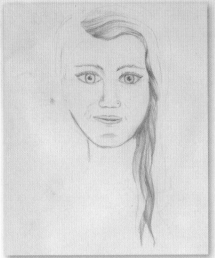

**Before and After by Taylor Cody**

**Before and After Examples**

In my Introduction to Illustration class, I ask students to draw a realistic rendering of someone they see every day from memory. After teaching them the techniques covered in this book, I ask them to create a set of portraits using photo references. As you can see in these students' examples, it wasn't that the students didn't know how to draw, it was simply that they didn't know what to draw.

**Before and After by Hannah Kirchner**

## WHEN NOT TO USE REFERENCE

There are times when it's not productive to use a reference, such as a quick drawing to flesh out an idea, sometimes called a *thumbnail sketch*. Thumbnails are meant to get ideas onto paper quickly by blocking in large shapes and forms. Gathering references for thumbnails slows down your process, thus defeating their purpose.

# GOOD VS. BAD REFERENCE PHOTOS

Choosing which reference to use can be difficult. Sometimes we fall in love with an image because of the colors, a look in the eyes, or some other detail that grabs us. That's fine for traditional photography, but your reference for a drawing should be more than just a pretty picture. Working with a poor or incorrect reference can be worse than working with no reference at all. In a way, a bad reference is like a friend that tells only half of a story, guiding you to a false conclusion.

So what makes a reference good? A good reference will accurately capture more information than needed to draw that image.

Your goal should be to capture every detail, even down to the pores in the skin. Most of the time you won't use that tight of detail, but it's always better to have too much information in a reference than too little. Also, a good reference will not be too dark, even in the darkest shadows. On the flip side, a good reference will not be too washed out in the highlights, and will show the transition from midtones to highlights. It's always possible to soften the shadows, but it is much more difficult to make them more pronounced.

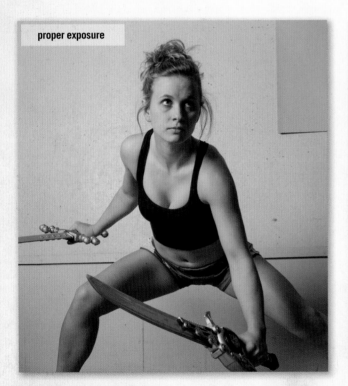

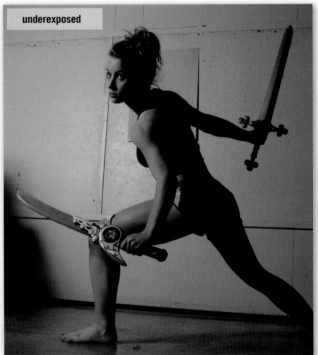

**Importance of Proper Exposure**
Always strive for a properly exposed, well-lit reference. On the left, the shadows are not too dark and allow you to see all of her musculature and angled limbs. Although the pose on the right is very energetic, the shadows on the back and arms are way too dark and would force you to come up with a lot of information from memory during the drawing process.

Visit impact-books.com/fantasyreference to download a free bonus art gallery

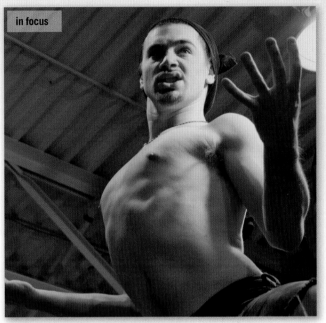

## Keep Your Main Subject in Focus

Never use an image that is out of focus for a reference. It makes it way too difficult to judge proportions, especially in faces.

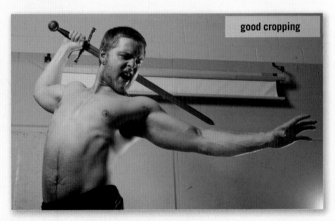

## The Magic of Cropping

Make sure that you don't zoom in too much or overcrop your shot. The left image is a good crop. It has all of the figure in it, so nothing needs to be added or made up. The right image is missing parts of both hands and the top of the head.

# PHOTOGRAPHY EQUIPMENT & DRAWING TOOLS

Being able to take your own photos is critical in being successful as a fantasy illustrator/artist. Every once in a while we can get by with found images such as stock photos or images pulled from the Web, but for the most part each drawing requires multiple, unique references to create successful characters. This doesn't mean you need to be a professional photographer; however, being comfortable behind a camera and making your own images will make you a much more effective storyteller.

The basic equipment you will need is a camera, lights and a few props. Although it is very easy to spend a small fortune on photography equipment, there are many ways to get fantastic references on a limited budget. My advice is to get the best equipment you can afford. If you can afford top-of-the-line strobe lights, that's great, but a couple of cheap spotlights from your local hardware store can work just as well. Knowing how to use your equipment is far more important than having fancy equipment.

## DIGITAL CAMERA

For reference photography, a digital camera with some manual controls is preferred. For example, you never want to shoot reference photos with a flash, so it's mandatory that you're able to turn the flash off. You also need to be able to shoot in dim to low light conditions without the image quality suffering. An SLR (single-lens reflex) camera will allow you to go completely manual as well as change the lens for different effects. The real power of an SLR is in the lens, so my advice when looking to buy an SLR is to spend less on the body of the camera, and more on the lenses. But be warned: It takes time and patience to learn how to use an SLR properly. There are also a number of point-and-shoot digital cameras that can create great images at a much more affordable price. Most point-and-shoots are easier to use than an SLR, but you lose some of the customization. Because there are many options and resources out there to help you choose the best camera for you, make sure to do your homework before buying one.

## LIGHTS

Light choice varies dramatically from artist to artist. Some spend a lot of money on professional studio lighting. Others use simple spotlights from a local hardware store that cost about as much as a couple of cups of coffee. Although studio lights offer the most control, you can get fantastic results with simple spotlights. The important thing to look for when selecting your lights is the ability to direct the lights from specific angles at your model. You want to avoid lamps and other ambient light sources since they are made to light a large area evenly.

To soften the light you can use the dimmers that come on the more expensive studio lights or defuse the light though something placed between the model and the lights. Before I bought studio lights, I hung a white bedsheet or a large piece of white paper between my model and the lights. Just be careful not to have anything too close to the lights; they get very hot!

SLR camera

flood light with reflector

Visit impact-books.com/fantasyreference to download a free bonus art gallery

tripod

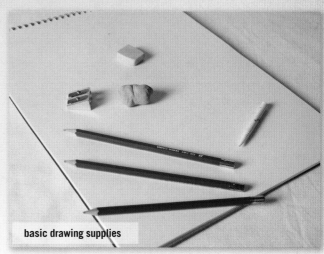

basic drawing supplies

## TRIPOD

If your camera doesn't have good vibration control, you will want to use a tripod to stabilize your camera so the images won't be blurry. A less expensive tripod is better for art references since many of the higher-end tripods have features you can easily get by without. Keep in mind that when using a tripod you will not be able to move around the model as easily. That said, a clear image is worth the added effort.

## PROPS

You can be very flexible when it comes to props and how much you spend on them. Just make sure you use something. A broom handle can work for a staff, and an old bathrobe from the thrift store can become a wizard's fancy robe. The key is to not have your model *pretend* to be holding something because it won't look natural when you try to draw that something in their hands. Make an effort to collect props even when you are not quite sure how you might eventually use them. I try to hit all of the post-Halloween sales for cheap plastic axes, swords and capes because I never know what I might need for the next drawing.

## BASIC DRAWING TOOLS

The basic materials that most artists use for drawing are pencils, a pencil sharpener, a variety of erasers and drawing paper. You can also use other tools such as graphite powder and sandpaper. In the end the materials you use for drawing are highly personal choices that give each artist their own style. You should always be open to experimentation and trying new techniques.

## PENCILS

Get a variety of art pencils ranging from 6H (lightest) to 8B (darkest) if you want to add softer, more realistic shading. You can also use mechanical pencils, which give a consistent line width. In the end, it's all about personal preference and whatever helps you get the results you want.

## ERASERS

This is your most important set of tools! You should have a standard white eraser, a kneaded eraser and a gum eraser.

## SHARPENER

You can use a standard hand-operated sharpener, an electric sharpener or a really sharp knife. Just make sure your sharpener doesn't break off the tip of your pencil but gives you a very fine point.

## PAPER

This is probably the most personal choice for an artist; just make sure whatever you choose is acid-free to keep it from yellowing and deteriorating with age.

# HOW TO SET UP YOUR LIGHTING

As a general rule, you always want to use two light sources. The first is the main light, sometimes called the *key light*, and is almost always the brighter light. When possible, try to light your model from an angle rather than straight on. Sometimes straight-on lighting can make the image appear flat, making it difficult to see the various planes and contours of the form. Your secondary light, also called the *fill light*, is to make sure the shadows don't get too dark. This light should be set up opposite the main light source and should be much softer and less intense. You will want to diffuse the secondary light in some way, either with a dimmer, or something as simple as placing a white bedsheet between the model and the light. It's essential that the main light is much brighter than the secondary light.

As you get better at lighting your models, you may want to add a third light for effects such as rim lighting, also called *backlighting*. Rim lighting is the bright edge of light around the shadowed edge of an image that you get when lighting the subject from behind. Don't be afraid to experiment and try new lighting for interesting effects!

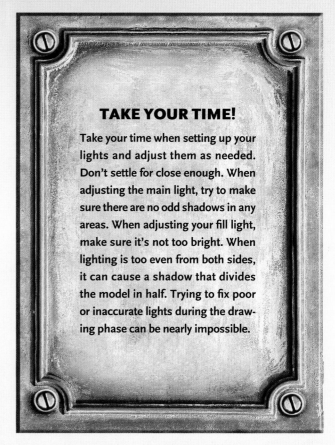

## TAKE YOUR TIME!

Take your time when setting up your lights and adjust them as needed. Don't settle for close enough. When adjusting the main light, try to make sure there are no odd shadows in any areas. When adjusting your fill light, make sure it's not too bright. When lighting is too even from both sides, it can cause a shadow that divides the model in half. Trying to fix poor or inaccurate lights during the drawing phase can be nearly impossible.

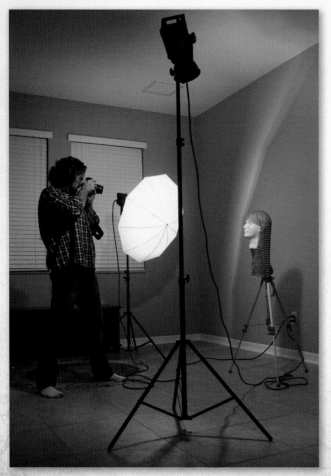

## My Lighting Setup

For most of my images, I use two Bowens Gemini 400 monolights mounted onto a tripod. I also have a Bowens Pulsar radio transmitter that triggers the lights. In this image, I am shooting a reference for chain mail coif armor. I am using an umbrella to bounce my main light (key light) to give it a softer light source. I am also using my second light to create some rim lighting.

Visit impact-books.com/fantasyreference to download a free bonus art gallery

key light

model

camera

*frontlit subject*

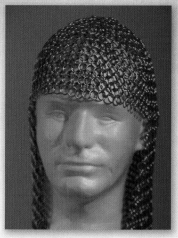

rim light

## Two-Light Setup

This diagram shows the basic two-light setup with a key light on one side and a diffused fill light on the other. When using this lighting setup make sure to have the fill light much softer than the key light or your subject will have a shadow down the middle.

---

*backlit subject*

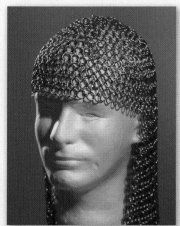

## Two-Light Rim Lighting Setup

This diagram shows how to achieve rim light using only two lights. First have your key light on one side, and then on the opposite side place the second light slightly behind the subject. This will create a highlight along the edge of the image. Careful not to get too far behind the image, as that will cause a backlight that will create a silhouette of your subject. Rim lighting is a fantastic way to make your figures stand out from a background and can make the figures appear more heroic as well.

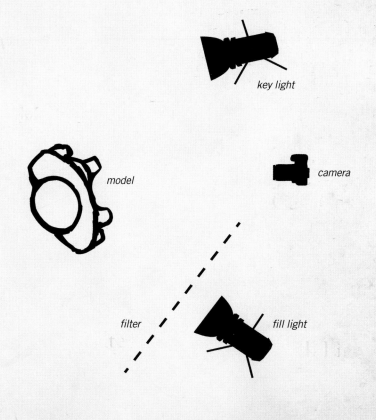

key light

model

camera

filter

fill light

# WORKING WITH A MODEL

Learning how to work with a model takes time and patience. There are no shortcuts or substitutes for experience. Your first couple of shoots will probably be a disaster. It took me almost three years to really get comfortable behind the camera. The key is not to give up. Learn something from each shoot and try to do a better job next time. Here are a few things you can do to make your first shoot less of a disaster. Hopefully you will end up with a handful of usable images.

## CHOOSE YOUR MODEL WISELY

Just because someone is attractive or has an athletic build does not always mean they will make a good model. Although these qualities can be helpful, other attributes are more important than physical appearance. Your model should have some acting ability and be flexible enough to show action in various poses. Most importantly, your model should have a positive attitude and be excited to work with you. Nothing will make a shoot turn sour faster than your model asking, "Are we done yet?" So remember, perfect features do not always equal a perfect model.

## WHAT TO WEAR

For males, I have found it works best to have them wear shorts. For females, a bikini or sports bra with shorts works best. I rarely shoot my models in costumes because they can hinder the flexibility of the model. Also it will take too much time to get all of the smaller details perfect such as folds in cloth. That's time I would rather spend experimenting with different poses and subtle expressions. Once I figure out what pose I will use for my drawing, I often do a second shoot to work out the costuming using a stand-in for the original model. Sometimes I will put my camera on a timer and use myself as the stand-in for costuming. It's not ideal because it can take two or three times as long to get the shot but it can work in a pinch.

## HAVE AN IDEA OF WHAT YOU WANT TO DO

Always work up some ideas before every shoot. These don't have to be elaborate sketches, but a few quick thumbnails of various poses can make the shoot go much smoother. It is good to be open to ideas the model might have for different poses, but don't rely on the model to come up with good poses for you. Finally, don't rely too much on your thumbnails. If something isn't working, be open to altering or changing the poses, even if they are different than your original idea.

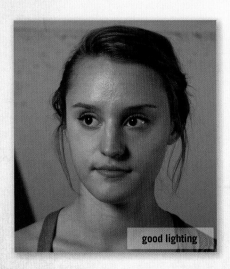

good lighting

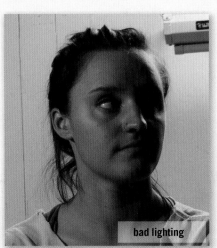

bad lighting

**Double-Check the Lighting**
Always take a few moments to double-check the lighting. Make sure there are no odd or too dark shadows. The image on the left has very dark shadows over half of the face which would make it very difficult to render those details. The image on the right has nice directional lighting that helps to form and unify the overall shape of the face.

Visit impact-books.com/fantasyreference to download a free bonus art gallery

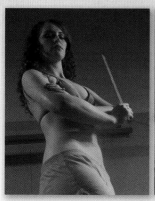  

## Vary Your Point of View

Don't just sit back and take pictures from one point of view. Move around the model and try different angles. Make sure to get close-ups on areas that have a lot of detail such as hands, faces and feet. Even though your overall image might be in perfect focus, a close-up will always show much more detail.

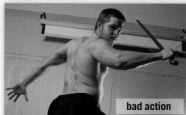

bad action

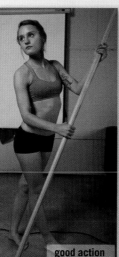 

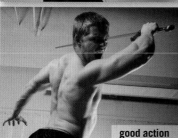

good action

good action

bad action

## Add More Action!

Capturing reference images that don't look stiff and overposed is difficult. It will probably take twenty to thirty minutes for both you and your model to loosen up enough to start getting decent movement in your images. Unless you are working with professional models, it will take time for your model to get into character. In the beginning of the shoot, put the model in poses that allow them to twist and bend a lot. If your images continue to turn out stiff, try having the model cross their legs or get into a sprinter's stance with the lower body. You can always "frankenstein" your references together (see the *Elf* demonstration in Part II). In these examples the images are basically the same, but a minor twist adds a great deal of energy and action to the pose.

## DOS AND DON'TS OF WORKING WITH A MODEL

1. Treat them like princes and princesses! Good models you can count on are a wonderful asset for any artist. It's very important that they have a good experience modeling for you so they will want to come back and work with you again. Being polite and respectful can go a long way in developing a good working relationship with your model.
2. Compensate your models in some way. Even if you cannot afford to pay them, offer them something for their time such as an original pencil drawing or cooking them a nice dinner.
3. Give the models regular breaks and don't ask them to hold a pose for more than 10 to 20 seconds.
4. After you have a handful of images, take a moment to show them to your model, explain what is working, and what you are looking for in an image.
5. Always be encouraging and positive even if you are struggling to get the image you need.
6. Unless they give you permission, DON'T EVER TOUCH THE MODEL! Even moving their hand is considered unprofessional.
7. Always use a model release. It will protect you, the model and anyone that might buy your art. You can find sample contracts on the Web that are free to use.

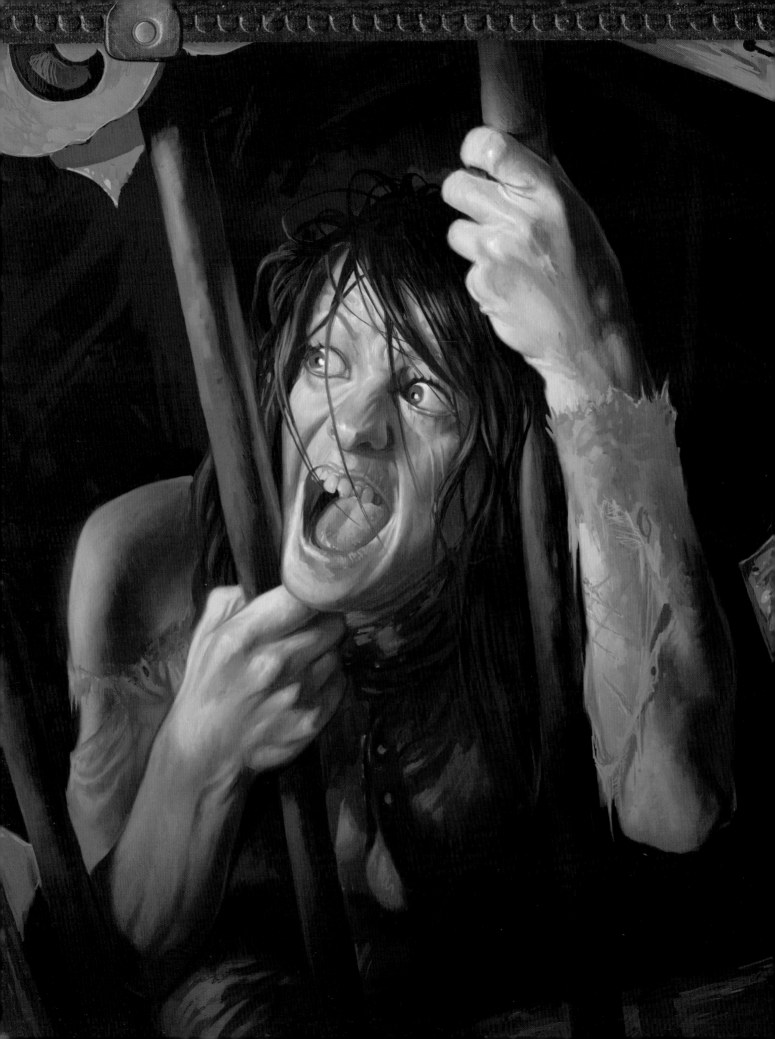

# DEMONSTRATIONS

Doing your homework and collecting solid references is a great start to a drawing, but its only half the battle. Now it's time to draw. There are many different techniques to working with a reference and each has it's upsides and downsides. There is no right or wrong way to work with a reference. This section shows you how to work with references using common methods of drawing such as gridding, freehand and tracing. We will start with individual characters and work toward compositions with multiple figures and actions. Give each method a try and decide which works best for you. Experiment with the techniques covered in this section to help you go beyond the photo reference and create unique fantasy characters of your own!

DESPERATE RAVINGS © Wizards of the Coast

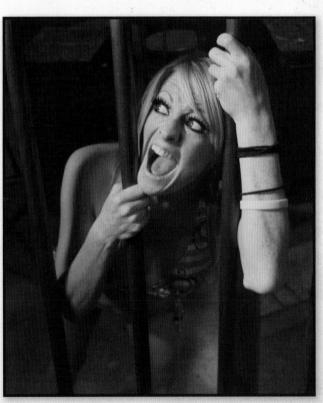

...thods for start-
...ng. When you
...pes and slowly
...asic geometric
...work your way
...e drawing and
check all proportions at each phase before moving forward. If

something doesn't look right, take a few moments and fix it. Not rushing any step is the key to a successful freehand drawing.

In this demonstration we want to portray a beautiful, powerful and intelligent sorceress. When choosing an image to draw, every aspect should help to tell a story. Before you begin the drawing process, consider the lighting, pose and point of view. Ask yourself if everything is consistent with the story you are trying to tell.

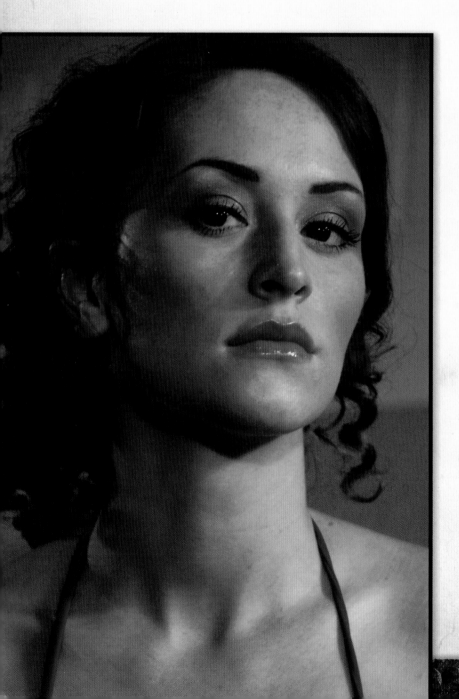

### The Story

"The room fell silent as Ellewin slowly turned to face the young captain. With one eyebrow slightly raised, she directed a penetrating glare upon him. It was obvious the great sorceress did not share his sense of humor ..."

### The Pose

The sorceress has been photographed at a three-quarter view, the head turned to the left and the model looking in the direction of the camera lens. This adds drama and movement to the pose, and lends a sense of mystery to her character. She has been photographed from below her face with her chin slightly raised to add a sense of power and confidence.

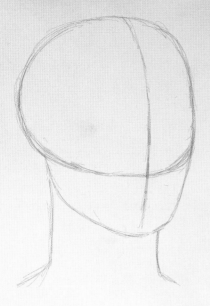

### Sketch the Large Forms

 Start with the basic head shape and establish a centerline that runs through the middle of the face.

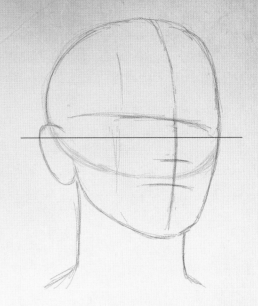

### Add the Facial Guidelines

2 Sketch guidelines for the mouth, nose and eye placement. The lines aren't straight but at about a 15-degree angle. Also add the simple ear shape.

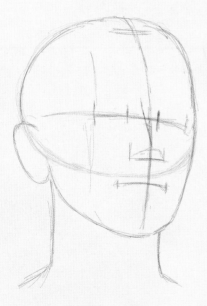

### Measure the Facial Features

3 Block in the basic width of the eyes, nose and mouth.

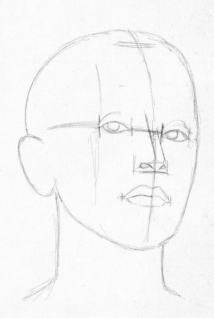

### Add the Basic Facial Details

 Draw the basic shapes of the eyes, lips and nose. Study a close-up of the nose reference because if you turn it up too much it might look too piglike.

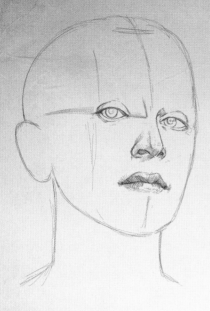

### 5 Shade the Face Shapes

Add shading to the nose area and remove any guidelines that are getting in the way. As you add shading make sure to consider your line direction to help create the forms. The eyes are the most important element of this image, so take extra care to get them right. Begin by adding more definition to the pupils, then put in the reflections. Add the upper eyelids and subtle shadows below the eyes. Shade both the upper and lower lips. Notice how the directions of the lines help to define the overall shape.

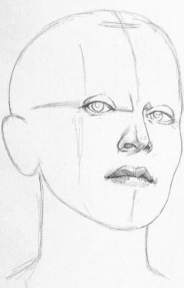

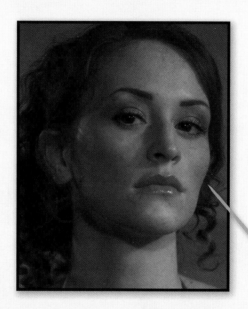

### 6 Shape the Cheekbones

Look closely at the reference photo to define the shape of the cheeks, giving her high, powerful cheekbones.

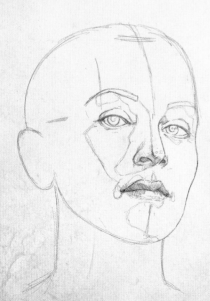

### 7 Block In the Facial Shadows

Add in guides where the shadows will fall on the face. Make your shapes as accurate as possible to make shading it in much easier. The most important thing here is to look for the change in the values and the more shapes you can add the better.

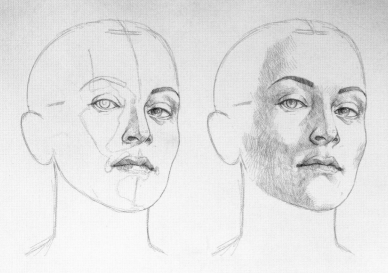

## Shade the Eyes, Nose and Face

Shade in the eyes, nose, cheeks and chin. Notice that the shadows are not just one tone but vary in lightness and darkness. Adding subtle changes in the values of the shadows will create great depth in the image.

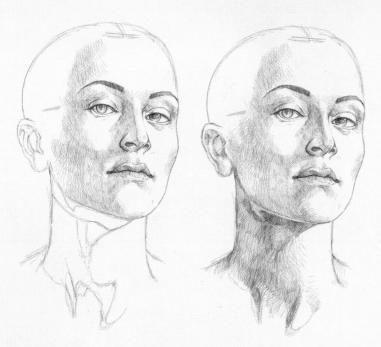

## 9 Block In and Shade the Neck Shadows

Block in and shade the shapes and shadows of the ear and the neck. The shadows on the neck are not all the same value. For example, the area right under the chin is much darker than the middle section of the neck. Shade accordingly.

## DRAW HARDER!

When art students first begin to study how to draw the figure, they tend to make lots of errors where lines are placed. Often these errors are only slightly off, maybe an angle is a couple of degrees off or the eyes are just a bit too high. When these errors are close to where they need to be, it's common for students to overlook them and think, *I'll just fix it later*, or ignore them altogether. This often leads to frustration at the final stages of an image when I hear the dreaded statement: "Something looks weird!" But by this point it's too late to figure out why.

This is why I push my students to *draw harder* at every phase of a drawing. Take time to look at your reference and study every aspect of it. Focus 100 percent when you put a line down and don't let your mind wander while you are drawing. Be sure that every line is right, and if it's not, erase it and make it right. There should be no such thing as "close enough"—it's either right or wrong.

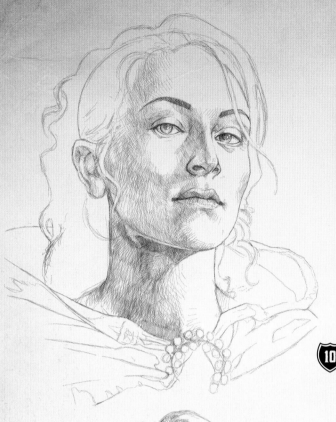

 **Add the Hair and Cloak**

Add in the forms of the hair and cloak. Draw in the hair in chunks, not individual strands. For this portrait the top of a cloak is implied. Although you could draw this from your imagination, for costuming elements it usually takes only about ten to twenty minutes to create a reference photo to work from. Having a reference will allow you to create realistic lighting and folds in the cloth much faster than if you had just made it up from memory. Notice that the lighting for the reference photo and the cloak are close to the same. It's critically important to maintain consistent lighting when selecting and shooting reference.

**Shade the Hair and Cloak**

Shade the hair and cloak, making sure to look closely at the reference for the subtle transitions. Cloth often has various areas of lighter and darker values in the shadows, so be careful not to shade all of the shadowed areas the same value.

 **Finishing Touches**

To finish the drawing, add unique details to create a mystical mood. I chose to add some beads to her hair and facial tattoos, but there are many elements you could add such as earrings, a gemmed choker and braids in her hair. I encourage you to try different things to make the image your own. The goal is to draw a beautiful sorceress, not just a girl in a cloak.

Visit impact-books.com/fantasyreference to download a free bonus art gallery

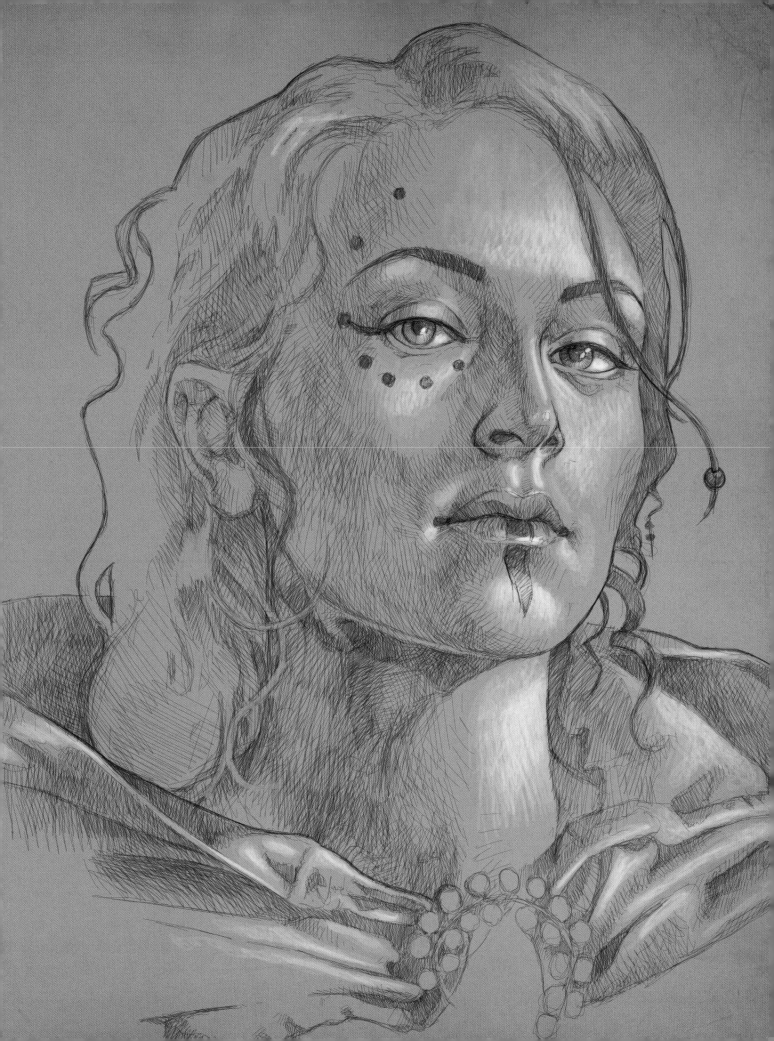

# BARBARIAN

Using a grid as a drawing aid can offer more accurate results than a simple freehand drawing, though it does involve some time to prepare the reference photo and the paper. Start by creating a set of vertical lines evenly spaced from each other over the reference. Make sure to note how far apart the lines are. Then, using the same distance between the lines, create a set of horizontal lines to form a grid over the reference photo. It is important that the lines are perfectly parallel and that each cell forms a perfect square. On your drawing paper create a grid that is twice as large as the grid on the reference. For example, on your reference you might use one inch (2.5cm) of space between all the lines, then on the drawing paper it might be two inches (5cm) between the lines. As long as your grid is made of perfect squares and has the same number of vertical and horizontal lines, you can use any size between the lines. Make sure to draw your lines very lightly because you will be erasing them once you have the basic form drawn in. After you've created your grid, you're ready to re-create what is in each space.

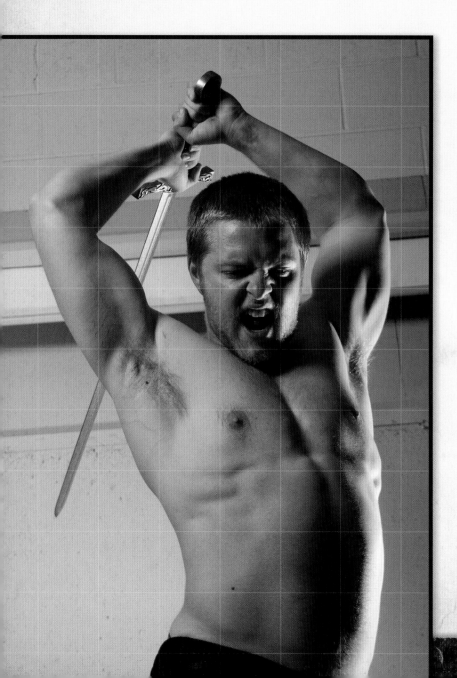

### The Story
"Kell rose up and lifted his great sword over his head in a tempest of rage and fury. Looking down upon the orc king, he let out a primal shout that embodied all of his hatred and vengeance for this evil creature ..."

### The Pose
This image was taken from a worm's-eye point of view using a main light with a rim light to help outline his form. Using a worm's-eye point of view will make the character appear more powerful and foreboding. For the lighting I used a low rim rather than a traditional side rim light to help make the character look like he is towering over the viewer.

### 1 Sketch the Large Forms
Draw ten horizontal lines and eight vertical lines very lightly on your drawing paper. Once you have a grid, start by creating the outline of the basic shape of the figure. Look closely at where the form intersects the grid and use that as a guide to see if your drawing is accurate. It is important that the lines are not just close but as perfect as you can make them.

### 2 Sketch the Face and Muscle Guidelines
Create reference points for the elements of the face, hands and muscles. Continue to keep all your lines very light until step 5.

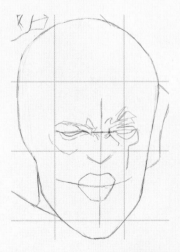
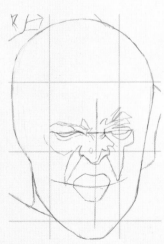
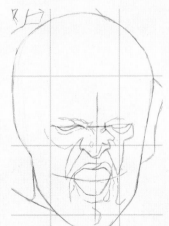
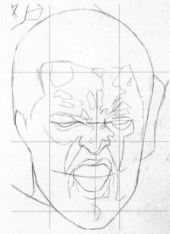

### 3 Add the Facial Features and Indicate the Shadows
Refine the shapes for the face by adding the eyes, nose, mouth and forehead. Also indicate the shapes of the highlights and shadows.

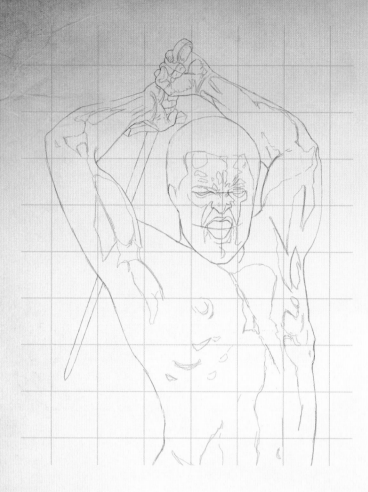

## 4 Indicate the Shadows and Highlights of the Arms and Chest

Continue adding shapes for the highlights and shadows of the arms and chest. Closely reference the lines in each square of your grid to make sure they are in the right spot. For example, make sure the curve in the chest shape is not drawn too straight. Once you are finished adding all of the guidelines of the arms and body, very carefully erase the grid. Try not to erase any of the figure.

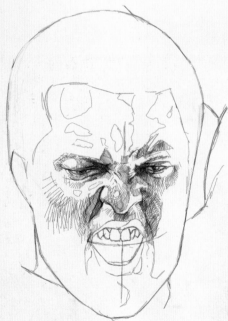

## 5 Shade the Eyes and Nose

Begin shading in the eyes and nose. Follow your guidelines but also look closely at the photo and adjust areas that are not quite right. Be careful to get the highlights and shadows right on the nose because if the nose is off, the entire face will look odd.

## 6 Shade the Mouth and Forehead

Add the shading for the mouth. Don't just create one big black shape for the mouth. Take the time to draw in the teeth and tongue to add energy to the expression of the face. Finish up the face by adding shading on the forehead.

### 7 Shade the Arms and Chest

Add shading to the left arm. Shade the top of the arm darker than the biceps. This helps make the arm look like it is angled back behind his head. Continue to shade the chest and right arm. Create light and dark shadows down the center of his chest.

**Hair Reference**

I highly suggest changing the hair of your models to be more fitting of a fantasy setting. If you draw the hair in a contemporary style it will look like a guy in a costume, not a barbarian.

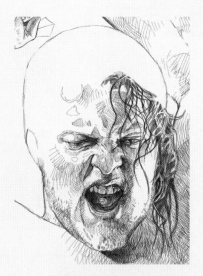

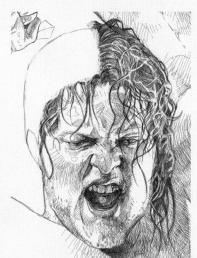

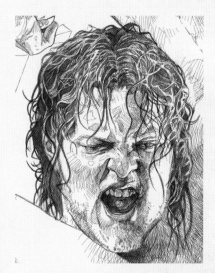

### 8 Shade the Hair Using a Separate Reference

For this drawing I wanted the hair to have more energy than that of the original model. I felt the hair should be longer and a bit more chaotic to show his barbaric nature, so I created a separate reference for the basic hair shapes and highlights.

Using the reference as a guide, add the basic shapes for the hair. Draw what feels natural to you and remember to draw the hair in sections or chunks, not individual strands. A barbarian would also work with a different style like braids or longer straight hair. Just make sure the lighting of the reference you use matches that of the original model.

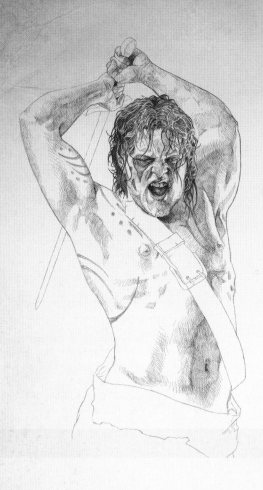

## 9 Draw the Belt, Fur, Sword and Tattoos

Using separate accessory references, draw in guidelines for the belt across the chest as well as the fur kilt. After the hair and face of your character are complete, it's usually a good time to add some fantasy elements so he becomes more than a shirtless guy with a sword. Add some body paint and tattoos to the figure and face. As you draw them make sure they follow the contour of the original form to keep the details from looking flat.

## 10 Shade the Belt, Fur and Sword

Shade in the highlights and shadows of the belt and fur kilt following the reference. The sword looks a bit small as originally sketched. Enlarge it while keeping the shape the same, then shade it in.

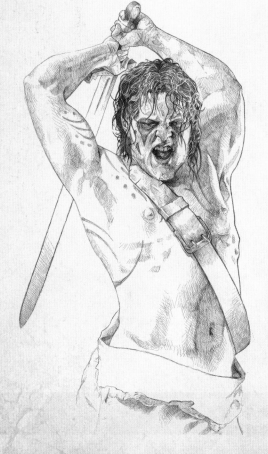

## 11 Finishing Touches

Continue to add fantasy elements such as rivets to the belt, an armband and wraps on the wrists.

### KEEP THE LIGHTING CONSISTENT

When combining references of different models and props, try to match the lighting to eliminate guesswork with shadows and highlights.

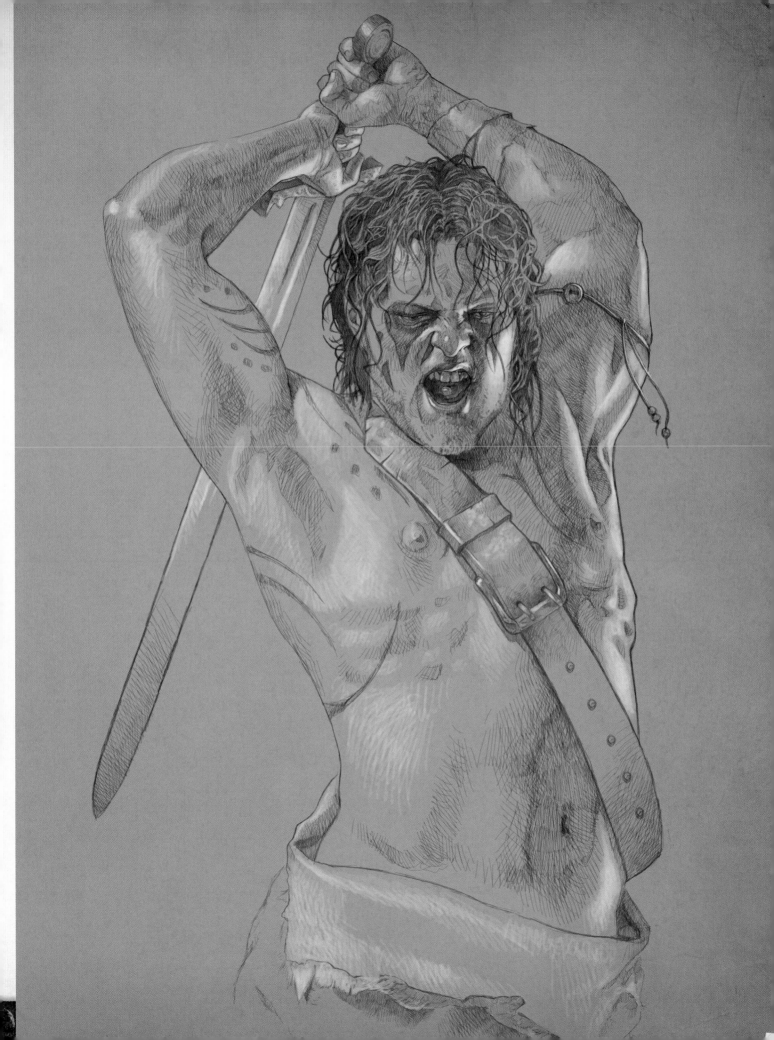

# DRUID

Tracing is a part of how we learn to draw as kids. Whether super-heroes or our favorite cartoon characters, it is often part of our first serious explorations into the world of making art. As our art skills grow, tracing reference photos can be used as a time-saving tool. Many professional artists and illustrators also use this as a time-saving device. That said, tracing should only be used as a guide, not a substitute for drawing. It is a method for quickly getting down proportions, values, planes and contours at the beginning of the drawing process.

The tools needed for tracing are generally less expensive than the projecting method. All you need is drawing paper, a light table and your reference. Make sure your reference is large enough to be able to draw from it. If you want to do a large drawing, a 3"× 5" (8cm × 13cm) reference isn't going to be compatible, so you will need to enlarge it to the desired drawing size. For a light table you can either purchase one or make your own using a glass-top table with a lamp underneath. You can also tape your drawing paper and reference to a windowpane on a sunny day.

### The Story
"Sela crouched down as she drew power from the bones that adorned her clothing. Most of her clan thought the bones were just ceremonial, but when she was just a child, she was taught the old magic. Sela could channel the beast's inner power through those bones. Now she called upon the stealth of the great saber cat to keep her unseen ..."

### The Pose
Here the model is looking to the right while her torso faces to the left. Having different sections of the figure facing opposite directions can help create action and tension in even the simplest of poses. Since she is crouched down, the point of view is also lowered so that she doesn't appear weak. A traditional rim light was used to make her look more heroic. Notice the subtle little elements such as the index finger of her left hand. That wonderful little detail would be difficult to make up without this reference.

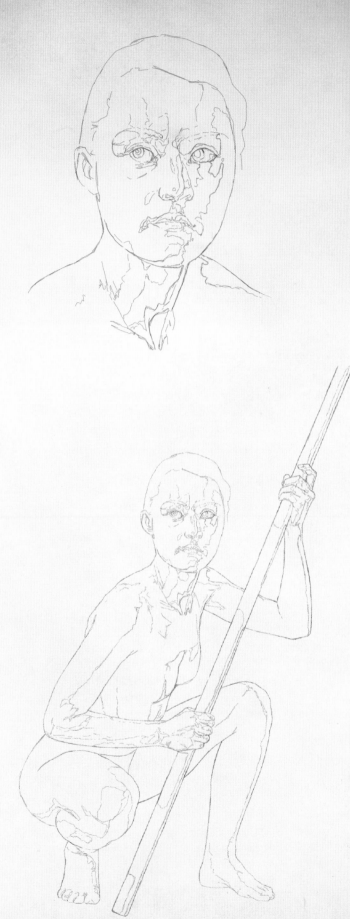

### 1 Sketch the Head and Face
After setting up your tracing method, trace the general lines of the head, face and neck. Make sure to include the changes in the shadows. It makes it much easier to shade when you know where to change the values.

## TRACING TIPS

Make sure to always tape the reference image to the light table; masking or drafting tape works best to prevent tearing. Then tape the drawing or tracing paper over the reference, leaving the bottom and sides untaped. This will allow you to lift up the tracing to make sure you don't miss any details.

### 2 Sketch the Torso, Arms, Legs and Staff
Continue to trace the torso, legs and arms. Don't worry too much about the clothing at this stage since it will be added later. Remember that the tracing is simply a guide to help you build your drawing during the beginning stages and not the finished art. Finish off the tracing by adding a general guide for the staff.

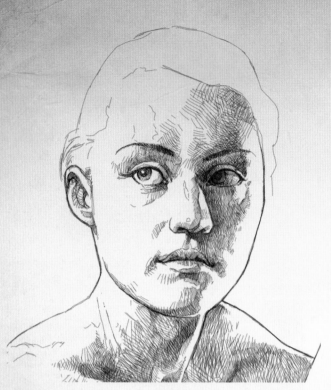

### 3 Shade the Eyes, Nose, Mouth and Face

Start adding details to the face. Even though the general shapes of the shadows were marked in the tracing stage, always look back to the reference to help decide how light or dark to make the shadows. No need to draw hair yet since the saber-toothed skull will be added later.

### 4 Shade the Legs and Torso Base

Continue to shade the arms, legs and torso. Save large areas of white where the costumes and details will be added later.

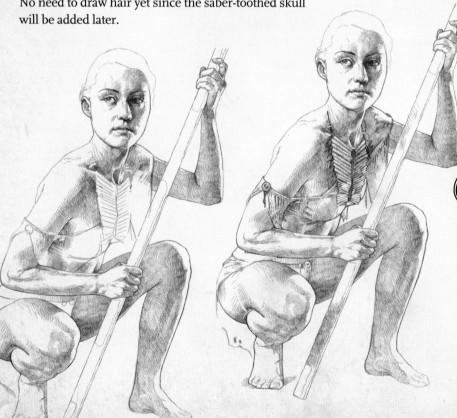

### 5 Outline and Shade the Costuming

The costuming for this character is loosely inspired by prehistoric and Native American clothing. Add basic shapes and lines for the bone necklace, leather top and loincloth, then shade them in. At this stage it's fine to add fun little elements such as beads and extra leather straps. This will add to the believability of the outfit.

Visit impact-books.com/fantasyreference to download a free bonus art gallery

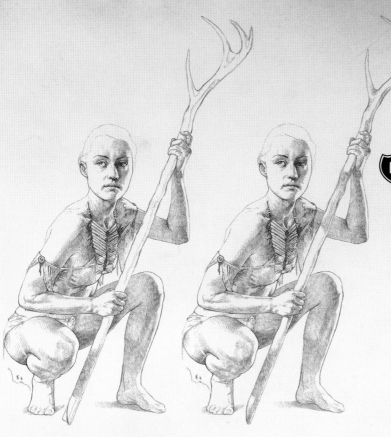

## 6 Embellish and Shade the Staff

Add to the basic shape of the staff. I've topped it off with animal horns to make it unique. Be creative here, but use a reference to get the shapes right! Shade the staff, making sure to keep the lighting consistent with the model.

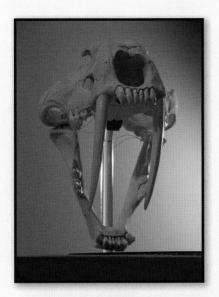

**Sabertoothed Reference**
The sabertoothed skull is the most important element of our fantasy character because it makes her unique. Study the skull closely and use the reference throughout the next few steps.

## 7 Sketch the Skull Forms

Sketch in the basic geometric forms. Note that in the reference, the saber-toothed tiger's fangs are very close together in a way that would hide the face of the model. I took some artistic liberty and widened the skull to sit on the model's head. Making the drawing look right is far more important than trying to be 100 percent accurate to the reference.

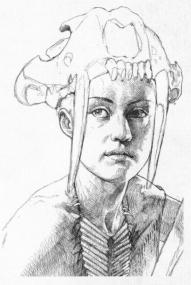

## 8 Refine the Skull Shapes

Refine the basic skull shapes, adding detail and shading to the eye sockets, nasal passage and teeth.

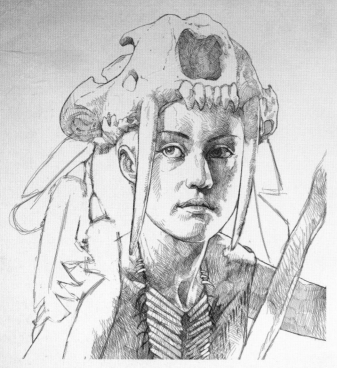

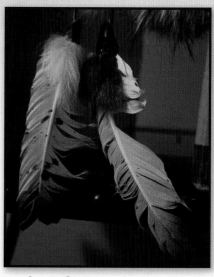

**Feather Reference**

**9** **Shade the Skull and Block In the Feather Forms**
Complete the shading of the basic skull forms. Don't forget details such as small cracks and holes in the skull. Using a reference, add some feathers to create unique adornments and balance the druid's headdress.

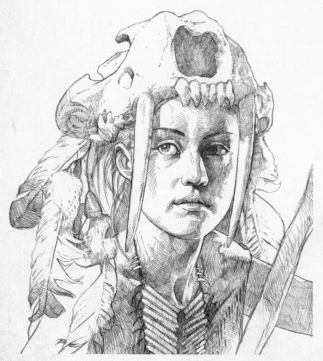

**10** **Shade the Headdress Details**
Shade the feathers and add a hint of hair between the ears and the feather.

## DON'T BE A SLAVE TO YOUR REFERENCE

Though a good reference can help you create more realistic drawings, great fantasy art also requires the artist to go beyond the photo. Many times a photo will capture details in a way that, though anatomically correct, look awkward when drawn realistically. Avoid getting too wrapped up in the photos. The goal is to create a fantastic drawing, not to be chained to photorealism.

**11** **Finishing Touches**
Since her pose is really compact, add some thicker lines to help separate her arms and legs so that they don't blend together.

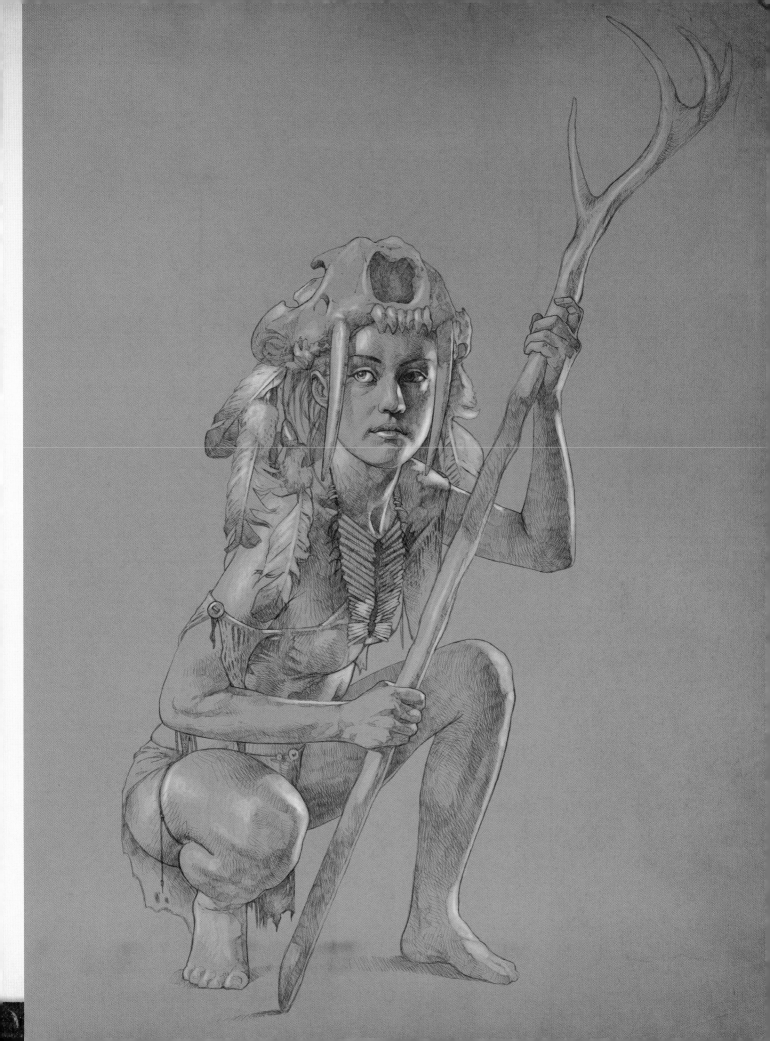

## USING A PROJECTION
# WIZARD

Methods of projecting a reference onto a drawing surface have been around for hundreds of years. There are many benefits to projecting. It is much faster and more accurate than the grid and freehand methods. This process also allows you to work much larger than by basic tracing. You can project your image onto just about any surface including canvas, Masonite or walls for murals.

The cost of a projector can be a significant investment. These can range from $50 for a simple opaque one to as high as $700 or more for a digital LED projector. You will need to use your projector in a dimly to darkly lit room in order to see the projected image. It is also important to work in a room where the projector will not be bumped or moved, and it's best if you can complete the contour guidelines all in one sitting.

To set up the space, start by adhering your drawing surface to the wall as straight as possible. If you are just using paper, some drafting tape will usually work fine. Next, position the projector so your reference is projected onto your working surface. Make sure that none of the image is outside of the paper. This sounds obvious, but it is a common mistake artists make due to the darkness of the room. When everything is in place, you are ready to begin tracing all the lines to your paper or surface.

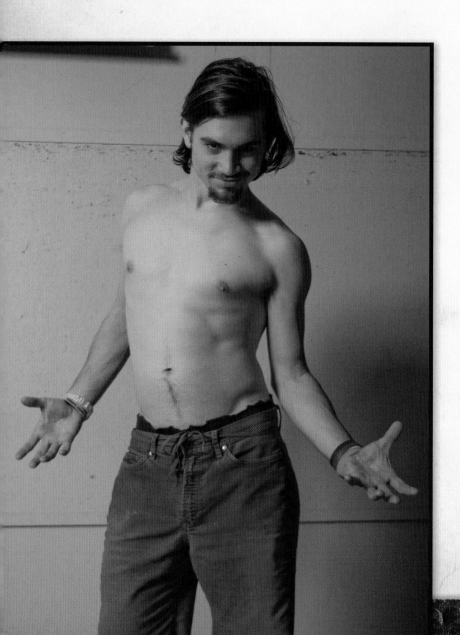

### The Story
"Aylon looked up and gave his former master a malevolent smile. As a small flame formed in his left hand, he proclaimed, 'I am more powerful than you could ever be ...' "

### The Pose
Although this is a simple pose, adding a weight shift in the hips and tilting down the chin makes for a more dynamic image. When working with your models its helpful to understand what they are really good at so you can play to those strengths. In this case the model was great at flexible poses as well as facial expressions, making him a great choice for a powerful wizard.

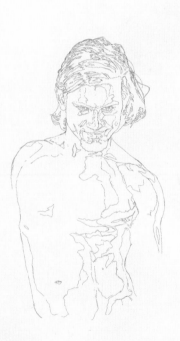

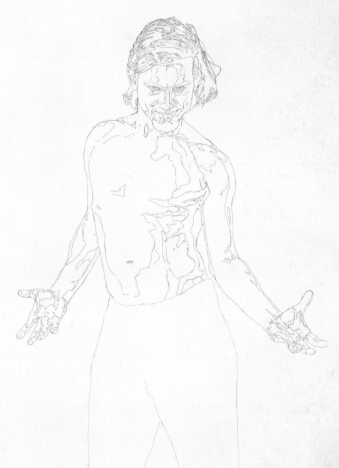

**1** **Draw the Contours of the Face and Body**
Begin by tracing the contours of the main form to serve
as a guide. Be as accurate and as detailed as possible
at this stage. Make sure to include shapes for shadows
and highlights. Start with the face, then add the hair,
chest, arms and legs.

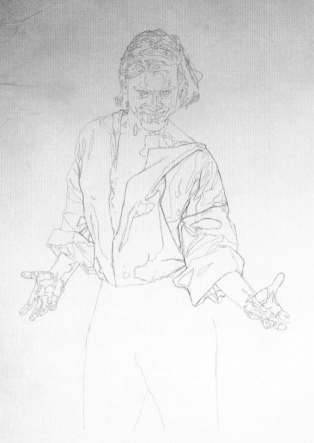

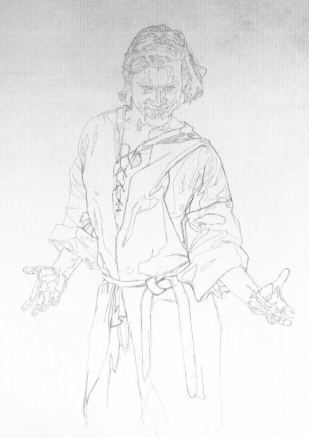

## ② Sketch the Upper Tunic

Add the contours of the clothing by working left to right. Since the reference was shot using a stand-in, it's easier to draw in the clothing rather than trying to project the reference on top of the figure.

## ③ Sketch the Undershirt, Lower Tunic and Belt

Add the shirt and its laces underneath the robe. Look closely at the edges of the cloth over the chest and add the slight curves to make it look more naturally form fitting. Add the belt and the lower half of the robe following the curve of the waist.

### Costume Reference

Whenever you are drawing complex clothing, try to add as many layers of clothing as possible. Add elements such as a shirt under the robe and stitching on the seams. This will help it feel more like a real outfit and less like a costume. The clothing doesn't need to be perfect to make it a good reference, but it should have as many details as possible. For example, in this reference there is a shirt under the robe, a leather tie on the shirt and an old robe belt that will become a worn leather belt. The important part is for the basic shapes to be accurate so you know what to draw.

Visit impact-books.com/fantasyreference to download a free bonus art gallery

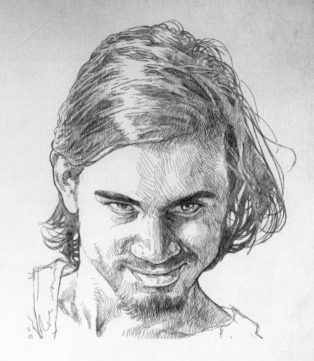

### 4 Shade the Face and Hair

Following your guidelines from step 1 and looking closely at the reference, add shadows to the face. Begin shading the hair, focusing on the areas of highlights and shadows.

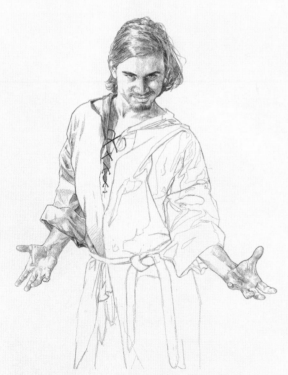
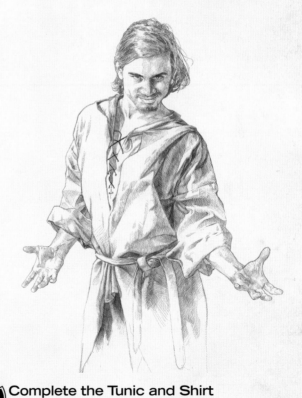

### 5 Shade the Hands and Left Arm

Shade in the hands, left arm and underside of the upper-left robe. Well-drawn hands can be almost as expressive as faces, so take care to get them right.

### 6 Complete the Tunic and Shirt

Shade in all of the cloth on the robe and the shirt. As a general rule when shading folds of the cloth there is a darker area as the shadow starts but it often lights up just a bit. Adding that transition will help add dimension to the cloth.

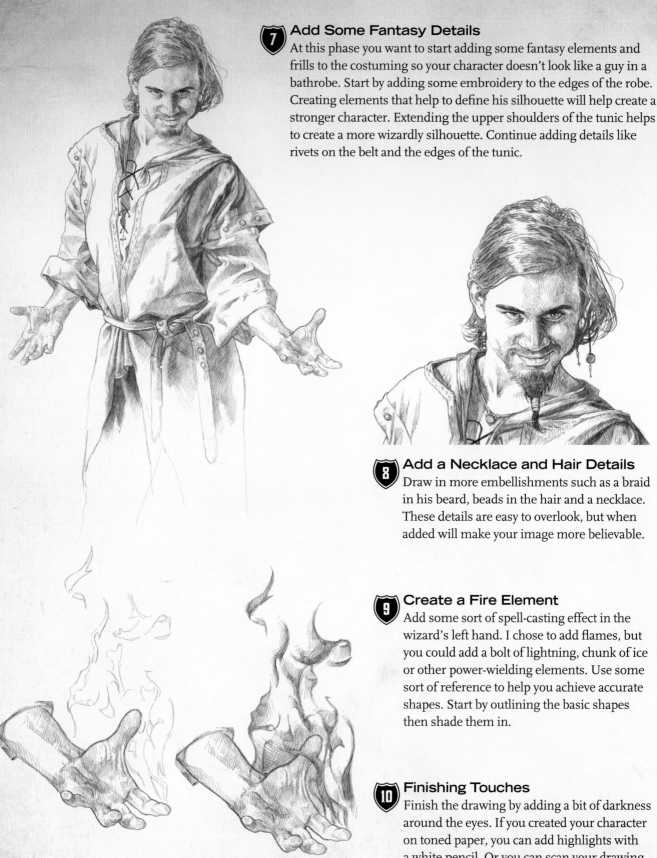

### 7 Add Some Fantasy Details
At this phase you want to start adding some fantasy elements and frills to the costuming so your character doesn't look like a guy in a bathrobe. Start by adding some embroidery to the edges of the robe. Creating elements that help to define his silhouette will help create a stronger character. Extending the upper shoulders of the tunic helps to create a more wizardly silhouette. Continue adding details like rivets on the belt and the edges of the tunic.

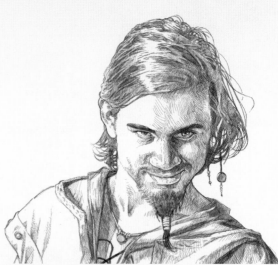

### 8 Add a Necklace and Hair Details
Draw in more embellishments such as a braid in his beard, beads in the hair and a necklace. These details are easy to overlook, but when added will make your image more believable.

### 9 Create a Fire Element
Add some sort of spell-casting effect in the wizard's left hand. I chose to add flames, but you could add a bolt of lightning, chunk of ice or other power-wielding elements. Use some sort of reference to help you achieve accurate shapes. Start by outlining the basic shapes then shade them in.

### 10 Finishing Touches
Finish the drawing by adding a bit of darkness around the eyes. If you created your character on toned paper, you can add highlights with a white pencil. Or you can scan your drawing and add highlights digitally.

Visit impact-books.com/fantasyreference to download a free bonus art gallery

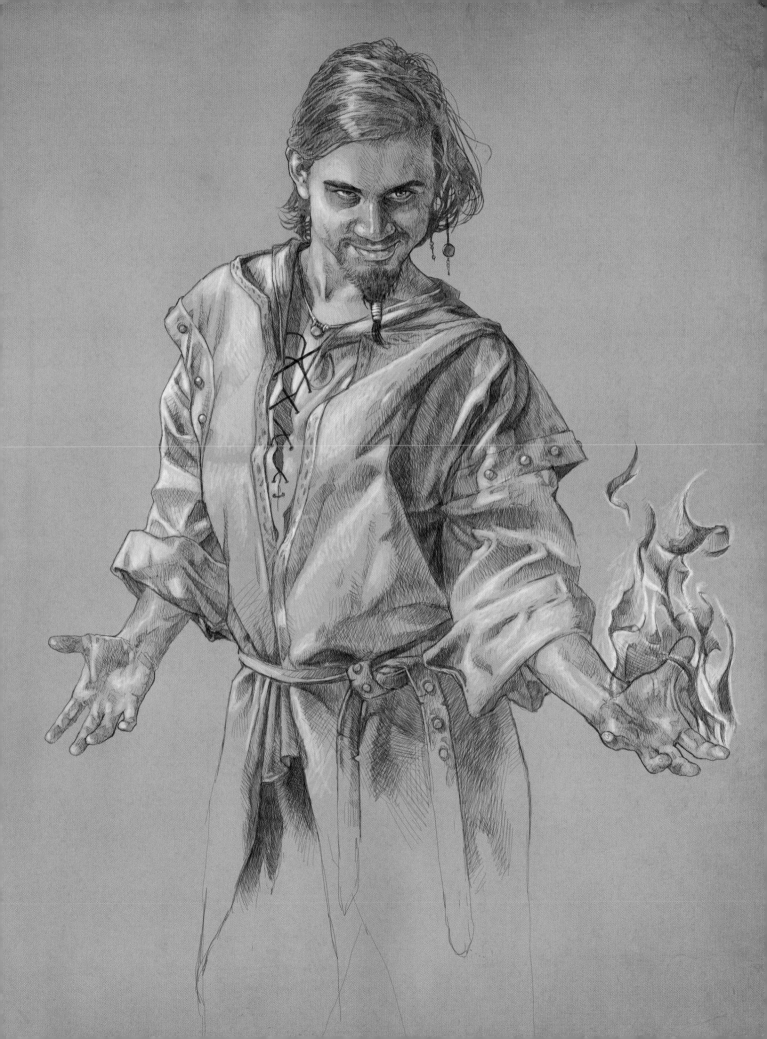

# DWARF

When learning to draw, we are usually taught to use a series of symbols and steps to create an image. For example, one might use an oblong circle, dividing lines, almond eyes and a triangle nose to draw a face. Using guidelines and general steps can work well when drawing from life or a reference, but drawing should *never* be done from a memorized pattern. Memorizing a set of steps and shapes to draw a face can teach you to draw that particular face. However, those specific patterns and shapes will not help you draw that same face from different angles or perspectives. At the same time, memorized symbols will never be helpful when drawing a vase, tree or animal. Learn how to break any image down to basic geometric forms, then build upon those to add and refine shapes. This will allow you to render anything you can imagine into a drawing!

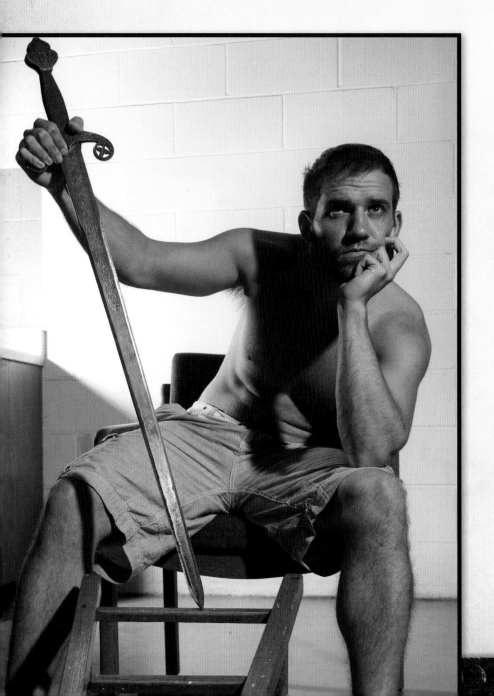

### The Story

"Olin sat as he listened to the young nobleman bicker and whine. All of those years of fighting to keep the borderlands safe from the goblins and for what? If this is what peace is, he wanted none of it. These thoughts made the old dwarf worry for the future of his people ..."

### The Pose

In this reference the lighting is slightly on the right side with a very subtle rim light to ensure the shadows on the face don't blend with the shoulder. The model leaning to the right while holding the sword at an angle forms an inverted triangle composition. The sword will later be changed to a halberd.

### Sketch the Basic Posture

Start this image by using a simple stick figure denoting the dwarf's sitting posture and how his weight is shifted. Denote the character's movement now before adding lots of details.

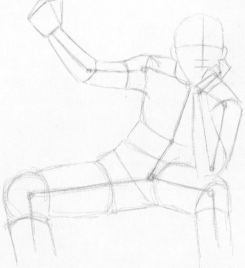

### Flesh Out the Form

Flesh out the overall form using simple lines and basic shapes. Concentrate on getting the pose and proportions right.

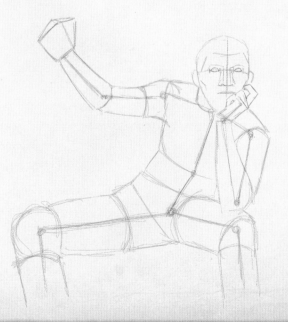

### Add Guidelines to the Face and Hands

Add basic guidelines denoting the hands and face. Remember that dwarf faces are wider and tend to have larger noses. It's important to use the reference as a guide for the shapes and values, but try not to follow it too closely or the dwarf may look like a full-size human.

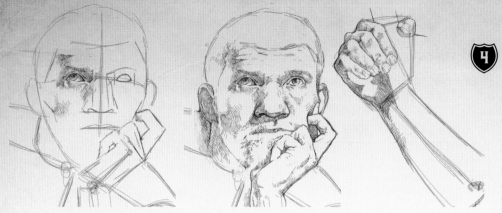

## 4 Shade the Face and Hands

Begin adding shading to the face and hands. Since armor will be added to the rest of the character, there is no need to shade the rest of the dwarf. Avoid shading too darkly on the chin area to leave space for the beard.

## 5 Add the Hair and Beard

Block in the basic shapes for the hair and beard. Pay attention to the lighting in the reference for placing the highlights. To add more of a dwarf-like feel, add bands that will break up the beard.

Shade in the hair, keeping the highlight to the upper right and making the lower left darker. Add a few extra strands of hair to keep it from being too perfect.

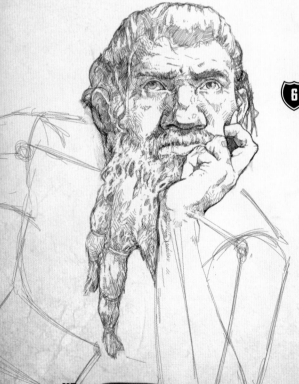

## 6 Shade the Beard and Add Wrinkles to the Face

Add shading to the beard using braided hair for reference. Add some wrinkles to age the face. Age lines and wrinkles on the face need to be very precise to be believable, so don't just guess where to put them. Most age lines and wrinkles begin when we are young adults and become more pronounced as we get older. Look closely at the reference and exaggerate the lines and wrinkles that are already apparent in the face.

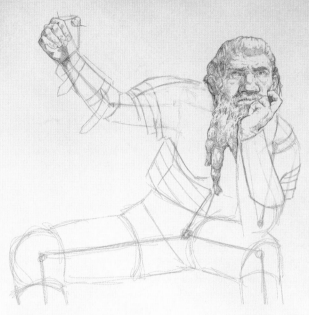

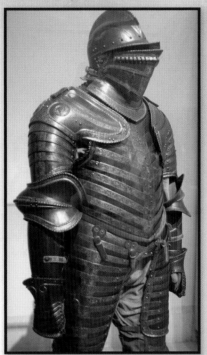

### 7 Block In the Body Armor

Using references of armor, add basic shapes to the shoulder, chest and arms. Pay close attention to the shape of the arm to get the fitted curve of the armor just right. Continue adding elements to the armor such as bracers. Good reference of the details saves you lots of guesswork with more complicated subjects like armor.

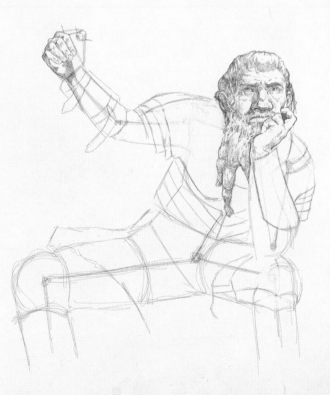

### 8 Block In the Leg Armor

Draw in the basic shapes for the leg armor and block in the shape for the fur kilt. In the reference I took, the fur kilt did not quite lie right for how I wanted to portray it. Don't be afraid to make adjustments.

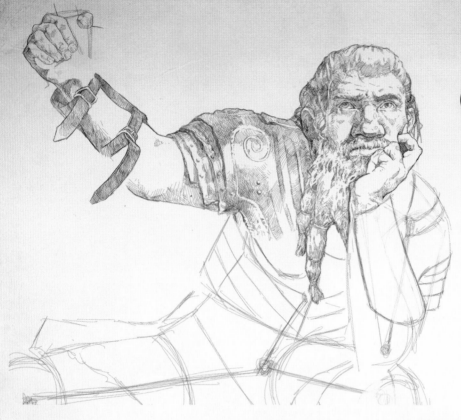

### 9 Begin Shading the Body Armor

Shade the body and forearm armor carving details into the metal such as small rivets. Adding some rough edges can make the armor look worn as if it has been used in battle. Try to keep the strokes a bit longer than what you sketched for the face and skin.

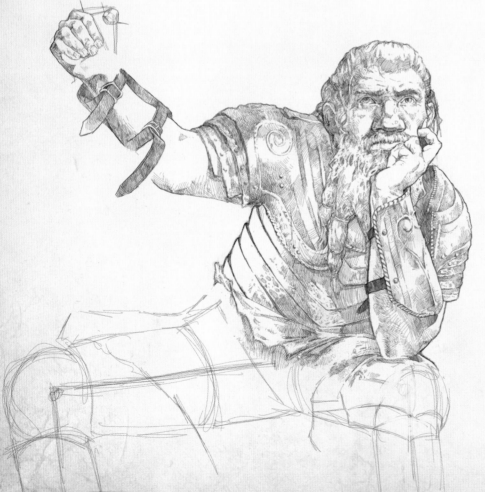

### 10 Add Details to the Body Armor

Continue to shade the armor. Make sure to add elements to keep the armor design consistent especially on the bracers. The reference for the bracers was simply for the basic shape. Add the detailed edging and swirled etching to create an overall consistent look. Continue to keep the strokes for the armor a bit longer than normal.

 **Begin Shading the Leg Armor**
Add shading to the armor on the leg on the right, still keeping the strokes a bit longer. Make sure to follow the reference since metal armor has dramatic changes in lights and darks. It is always a good idea to have some form of reference to use when trying to draw anything metal.

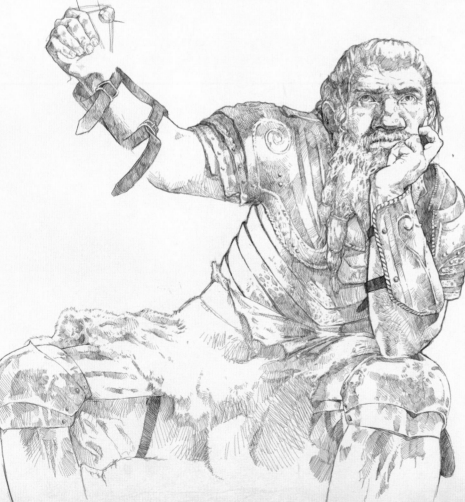

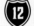 **Shade the Fur Kilt**
Shade in the fur kilt and the leg on the left. Anytime you have two different textures next to each other, it's important to draw them differently. Fur is very different than metal, so use small, quick strokes to give it a soft, fuzzy texture. Continue with longer strokes on the armor to show the contrasting texture of the fur.

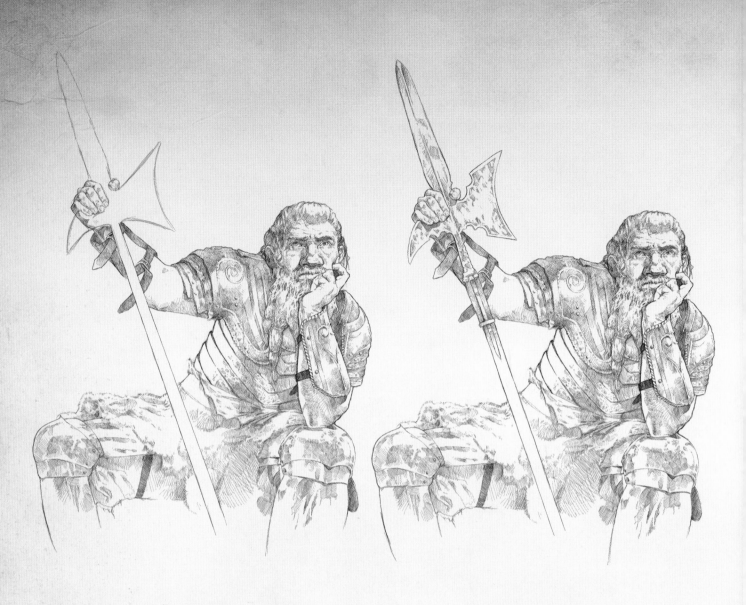

### 🛡13 Block In the Weapon
Lightly block in the basic shape of the halberd. Make sure to keep the staff straight and use a ruler if you need to.

### 🛡14 Shade the Weapon and Add the Background
Add the shading to the halberd. Little details such as rivets and etchings on the head of the halberd can make it even more believable.

### 🛡15 Finishing Touches
For the finishing touches add more details to enhance the story. I placed the dwarf on a massive throne. Always remember to work from a good reference!

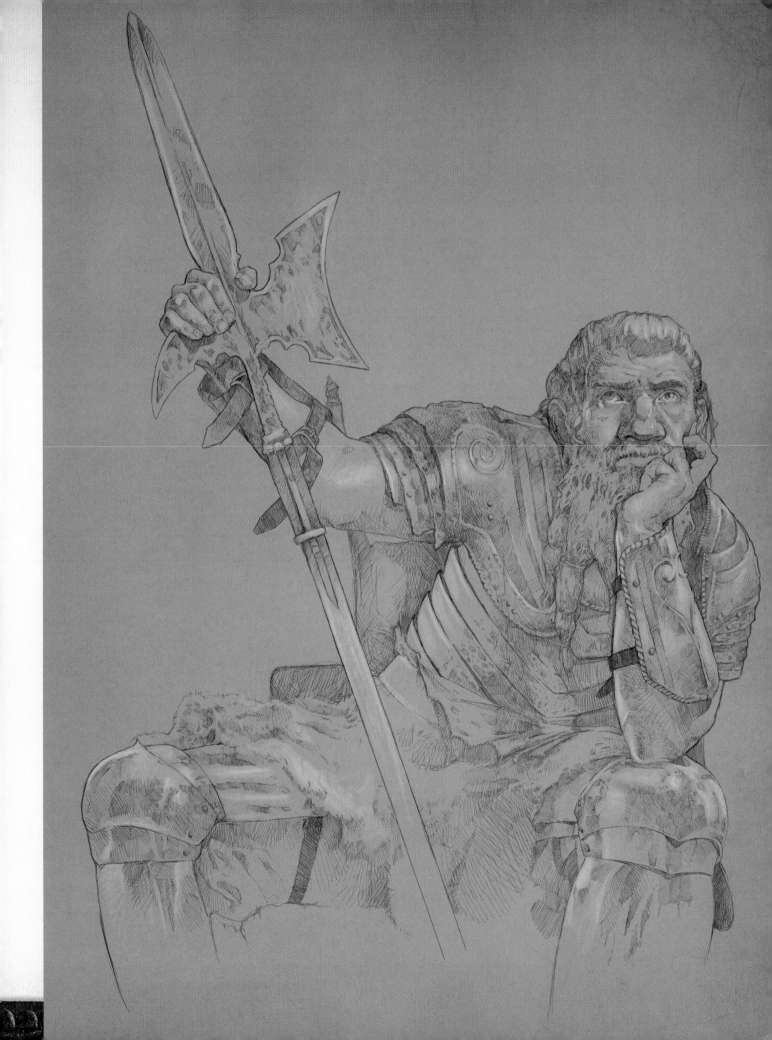

# GUARDIAN ANGEL

Action references can be some of the most difficult shots to get. Sometimes it isn't possible or practical to take a photo with the model performing an action such as running or flying. In this case it can be helpful to combine one reference for the body and a different reference for the legs to create a believable image that would be impossible to get in one shot. It's helpful to figure out during the shoot where you plan to combine references during the drawing phase. This will allow you to concentrate on smaller aspects of the pose without asking the model to balance or twist in ways that are not humanly possible.

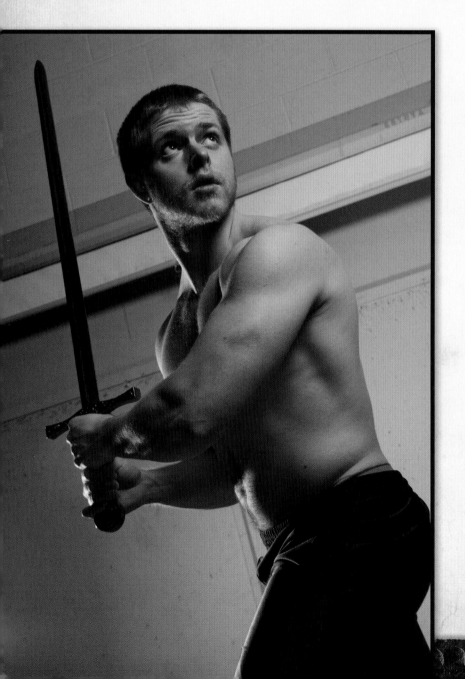

### The Story
"... and as the archangel rose up, he called upon the power of the almighty through his sword. He knew he would need all of his strength to battle this demon. As if to answer his call, the clouds broke and bathed him in glowing sunlight ..."

### The Pose
To create a sense that the angel is flying, I chose to capture the model from a low point of view. I focused one set of images on the upper body and shot the legs separately adding them to the drawing at a later stage. This way the model didn't have to try to balance on one foot.

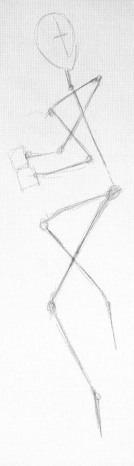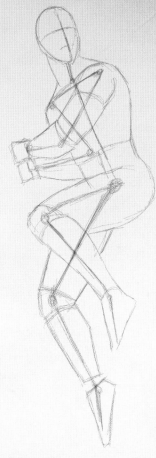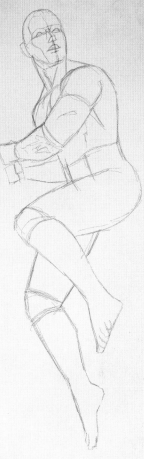

### 1 Sketch the Pose
Start by creating a basic stick figure for the character. Look closely at the reference to help draw it, and notice little details like the forearms are much shorter due to their angle.

### 2 Block In the Large Forms
Add the basic figure lines over the stick figure. Make sure to include the curves for the arms, chest and legs to help develop the form.

### 3 Refine Body Guidelines
Continue to refine the basic shapes on the face, then remove the stick figure lines of the body so the image doesn't get too cluttered.

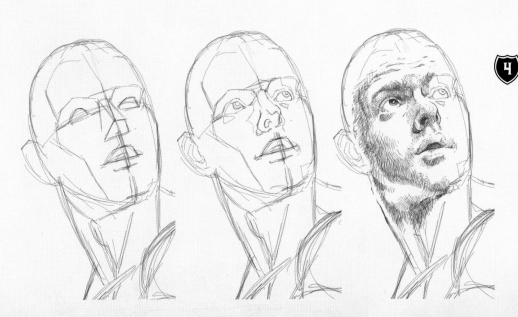

### 4 Block In and Shade the Face
Add some guidelines for the details of the face including the nose, eyes, mouth and ear. Shade in the face using the reference shadows and highlights as a guide.

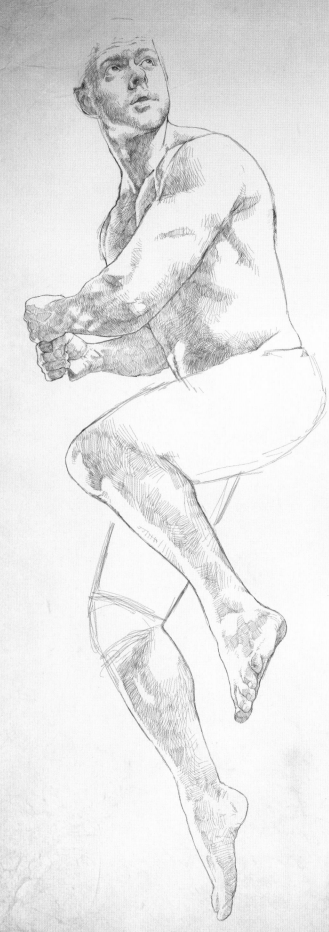

 **Shade the Arms and Chest**
Shade the arms and chest, taking care not to get too dark in the shadows. Since he will have cloth over his thigh, there is no need to fill in that area.

 **Shade the Legs**
Shade in the legs using two different references to help the angel look like he is flying. Since the original reference does not include the legs below the waist, I created two separate images after the original shoot. Always be open to changing or adding to a pose halfway through a drawing if it needs something extra to make it work.

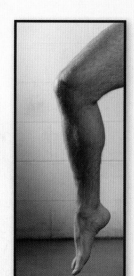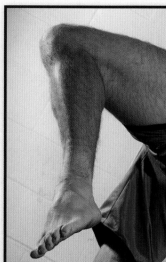

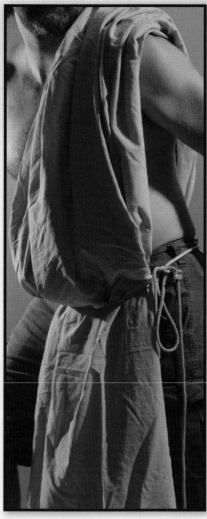

**Tunic Reference**
I shot this cloth reference to use as inspiration for the lighting and folds on the fabric, not as an exact replica.

**⑦ Block In and Shade the Tunic**
Block in the shapes of the cloth tunic. The wonderful thing about cloth is as long as the folds are natural, it can make almost any shape you need it to for a composition. Shade in the cloth paying close attention to the direction of the lighting, which is coming from the right.

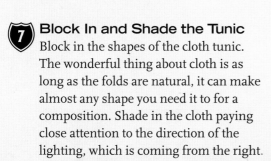

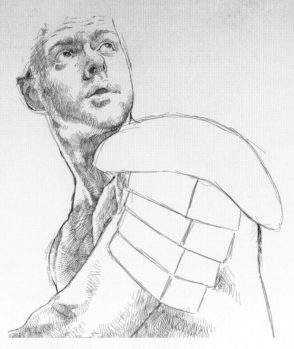

## Armor Reference

Like the legs, the armor was added after the original shoot with the model. Since both references have the same angle and lighting, it's seamless to combine them in the drawing.

**8 Block In the Armor**

Block in the basic shapes for the armor on the shoulder. Follow the reference to make sure the armor looks like it fits the guardian angel's body.

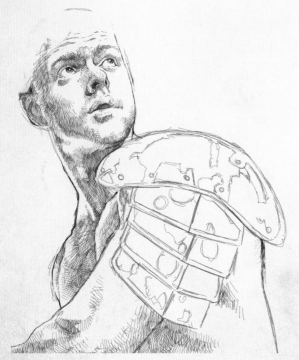

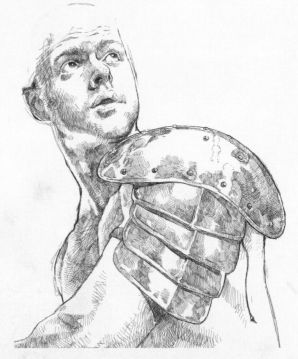

**9 Block In the Armor's Shadows & Highlights**

Create guidelines for the light and dark areas on the metal armor.

**10 Shade the Armor**

Shade in the armor. Refer to your reference because it's easy to accidentally shade in a highlight.

Visit impact-books.com/fantasyreference to download a free bonus art gallery

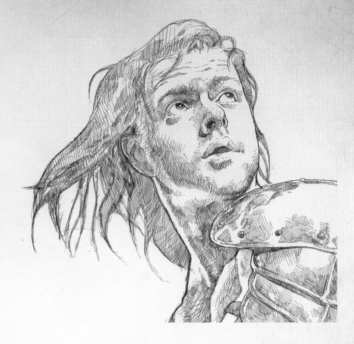

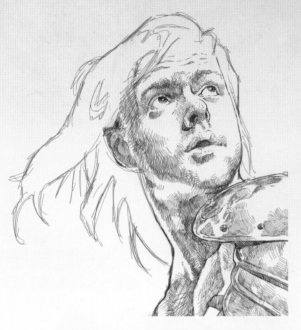

### 11 Block In and Shade the Hair

Block in the basic shapes for the hair. Since the angel is flying, the hair needs to be flowing. Little details like flowing hair can help make the image even more believable. Continue by shading in the hair, keeping the highlights on the right.

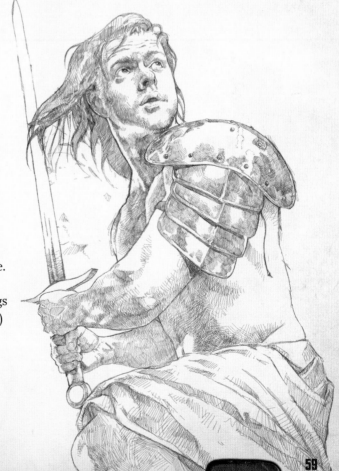

### 12 Block In and Shade the Sword

Block in the basic shape of the sword. Make sure to keep the blade straight and elongate the hilt from what is in the original reference. Shade in the sword keeping it darker at the hilt, then lighter behind his hair. (Note: wings will be added in following steps, sans sword.)

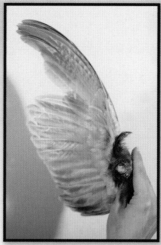
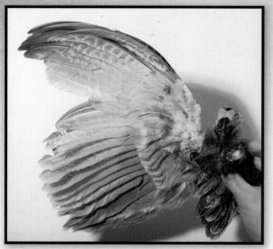

## Wing Reference

It would have been difficult to build wings for the model to wear in the original reference, so I substituted a pheasant wing for reference. I was very careful to ensure that the lighting and perspective were consistent in the photographs I snapped.

 **Block In the Wings**

Block in the basic shape for the wings. Keep the shapes simple, and focus on making the angle consistent with the body.

 **Shade the Wings**

Once you have the basic shapes, lightly add the details for the wings. Don't add too much detail to the wings. In this case less is more.

 **Finishing Touches**

Make the image your own by adding all sorts of extra details such as etchings on the armor, elongating the sword blade and adding writing to the cloth tunic.

Visit impact-books.com/fantasyreference to download a free bonus art gallery

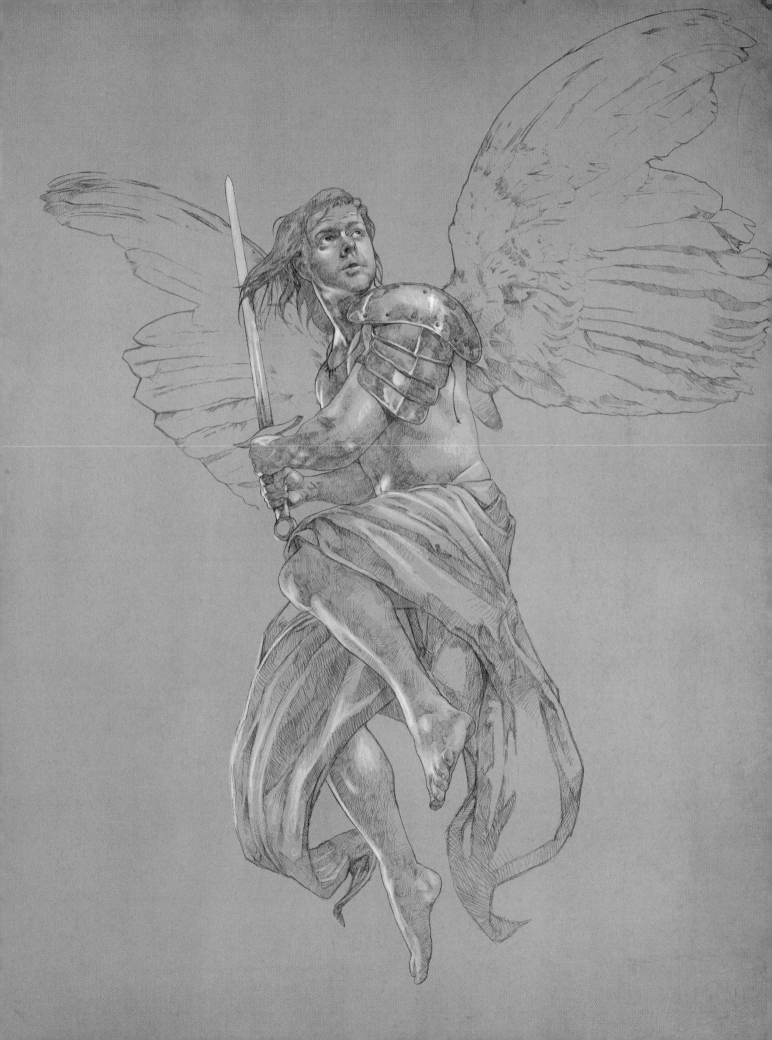

# FRANKENSTEINING YOUR REFERENCE
## ELF

In a perfect world you would have one photo reference that has everything you need to create a fantastic drawing. As artists, we are frequently forced to bring to together various images in order to create the "perfect" reference. The process of combining many different references in this manner is known as *frankensteining*. Most artists use digital photo editing software such as Photoshop to combine their images. This allows them to quickly scale, cut and paste and edit their images together.

A number of factors are involved in creating a successful frankensteined reference. The most obvious is that you should use elements only from the same sex of models. For example, do not put male hands on a female model as this will look very odd when drawn. Second, it is critical that the lighting be consistent. Even when the photos come from the same photo shoot, you should make sure that the lighting is the same intensity and from the same direction. Finally, pay close attention to the anatomy. A common mistake is making elements too large or too small. For example, it is easy to paste on a foot from a different image and make it too small for the figure.

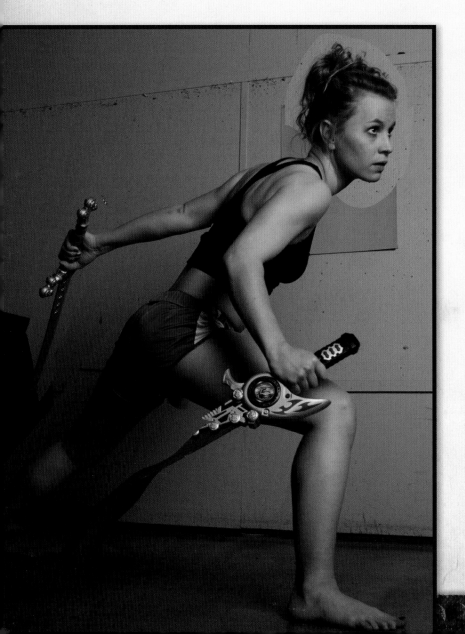

### The Story
"Avelli was distinctly one with the forest. She wore a chain shirt that was covered in a patchwork of furs and leather, and her hair was made of branches from a tree. Brandishing a long dagger in each hand, she moved with extraordinary speed and grace ..."

### The Combined Pose
The base image (figure A on facing page) was close to what I wanted, but I felt the action could be pushed even more. I also felt her facial expression could be a bit less posed so I found an outtake with a more ideal expression—her mouth slightly open adding some drama as well as a sense of anticipation (figure C on facing page).

To accomplish the combined pose, I used Photoshop to digitally enlarge the back arm of the base image to make it look more natural and compensate for the distortion from the camera. I then frankensteined the head and back leg (figure B on facing page) as seamlessly as possible to get the pose I wanted.

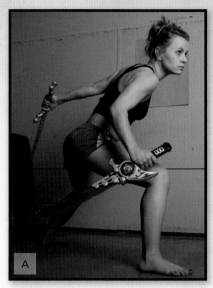

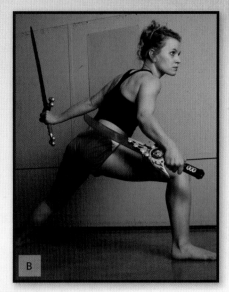

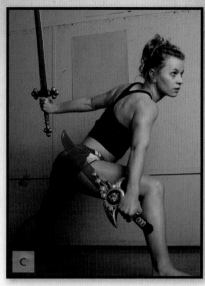

### Base Image

Start by selecting a base image. This will be the foundation for your reference. Most of the image should be what you want, with just a few details that need to be tweaked. If too many things need to be changed, you might want to select a different image for the base. In this example I selected the base image because of the energy in the pose; however, the angle of the face was a bit too flat and the back leg made her feel too compacted.

### Back Leg Reference

Using this image for her back leg will add more forward momentum and energy. Notice that all three of these images have very consistent lighting with just minor variations in the pose.

### Head Reference

I used this image for the head because of the subtle tilt and because her mouth is open just a bit. These may seem like minor details, but they help to add more energy to the drawing and the character's story.

## HOW TO USE PHOTO EDITING SOFTWARE

Digital photography and digital editing software have revolutionized the artist's ability to create art. Making use of these tools not only to create your photo references, but also to improve your drawings, is a critical part of becoming a successful artist in today's culture. There are many different sources available for all types of learners to educate themselves on digital software. Not learning them will greatly reduce your ability to make art both today and in the future. The standards are Adobe® Photoshop® and Corel® Painter™, though there are also open source (free) options, such as GIMP, available on the Web. Here are the basic steps I use to create a simple value study using your drawing.

1. Scan your drawing at 300dpi (300ppi) on the largest size and open it in Photoshop.
2. Double click on the background layer to unlock it, and name it "drawing."
3. Change the layer effect of the drawing layer to multiply.
4. Create a new layer, name it "white" and fill it with white.
5. Drop the "white" layer below the "drawing" layer.
6. Create a new layer, name it "black"and fill it with black. Change the opacity to 40%.
7. Create a layer between the "black" layer and the "drawing" layer, and name it "highlights."
8. On the "highlights" layer and using the default round brush set at 10% opacity, use your reference photo to add highlights.

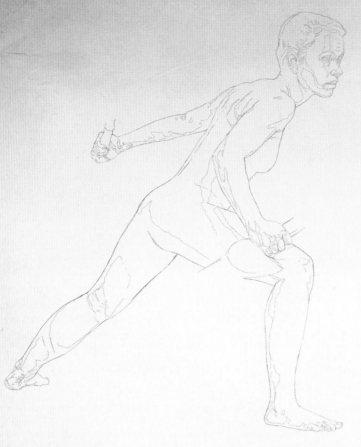

## 1  Trace the Basic Forms of the Face and Body

For this drawing I used the tracing method used in the *Druid* demo, but you could use a grid or projection to get similar results. Start by drawing the contours for the head, putting in guides for all of the shadows and highlights. At this phase just block in the basic shape of the hair. Add the contours for the arms, torso and legs. Just indicate the hilts of the swords. Remember that tracing is *not* drawing. It is only a basic guide to draw from to make the rendering faster and more accurate.

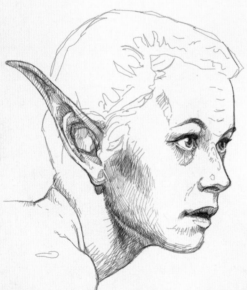

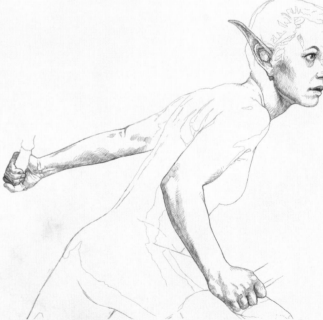

## 2  Shade the Face and Ear

Once you have all of the contours drawn, begin shading the face. Make sure to keep the facial features soft since it will be a female elf. Add the elf ear. Do not simply make a point on the end of a human ear, but adjust the anatomy so her elf ear is more believable.

## 3  Shade the Arms and Hands

Shade in the arms and the hands, paying especially close attention to the hands. They need to look like she is gripping the swords, not just making fists.

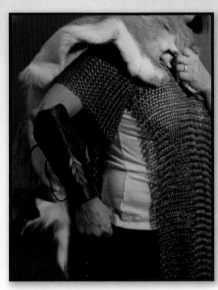

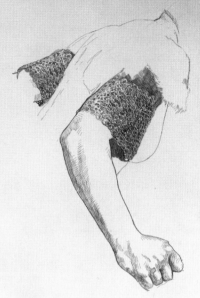

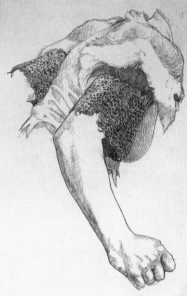

## Reference for Armor

I created a reference photo of furs layered over chain mail armor and leather sleeves to make up the elfin outfit. Our elf is wearing a combination of chain mail, leather and furs. Chain mail is made of hundreds of tiny rings linked together and can be complicated to draw, so reference is particularly useful to render it realistically.

**4** ## Draw the Chain Mail

Draw in the chain mail on the arms. The level of detail used in the chain mail can vary from implied to highly realistic, depending on your preference.

**5** ## Add the Fur

Add the fur on the shoulders and the leather shirt. Use quick, short strokes to depict softer texture.

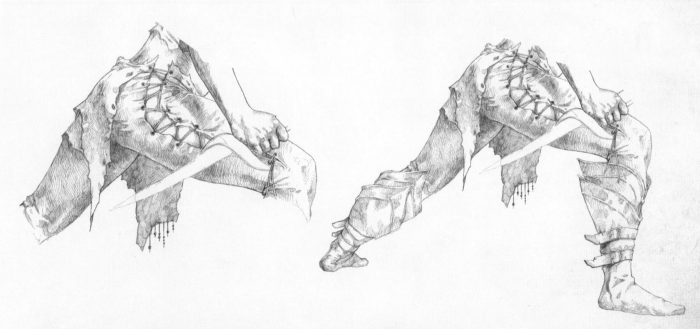

**6** ## Block In and Shade the Pants

Draw in the pants, adding stitching along the leg. Add small eyeholes where the laces weave in and out.

**7** ## Draw the Boots

Draw in the boots creating a few layers of leather along with straps and buckles.

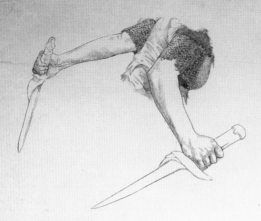
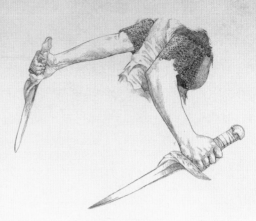

### 8 Block In the Weapons
Create a contour for the weapons. Try to create something unique instead of simply copying the swords in the reference.

### 9 Shade the Swords
Shade in the swords and handles. Keep the blade lighter so it doesn't blend into the pants.

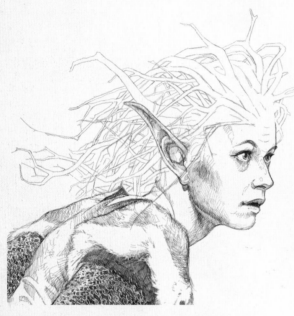
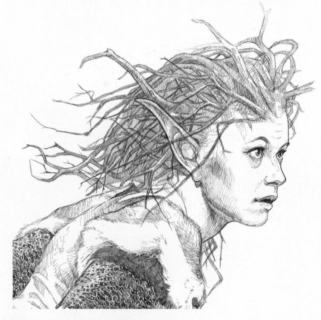

### 10 Block In the Hair
Using the tree reference as a guide, block in the shapes for the hair. Don't be afraid to experiment with the drawing. I used branches for the hair, but you could add leaves instead.

### 11 Shade the Hair
Once you have finished the outlines, shade in the hair leaving the ear visible.

**Hair Reference**

### 12 Finishing Touches
Continue to refine the drawing specific to your own taste. For example, I changed a few features on the face—her eyebrows and lips—to make the elf more exotic.

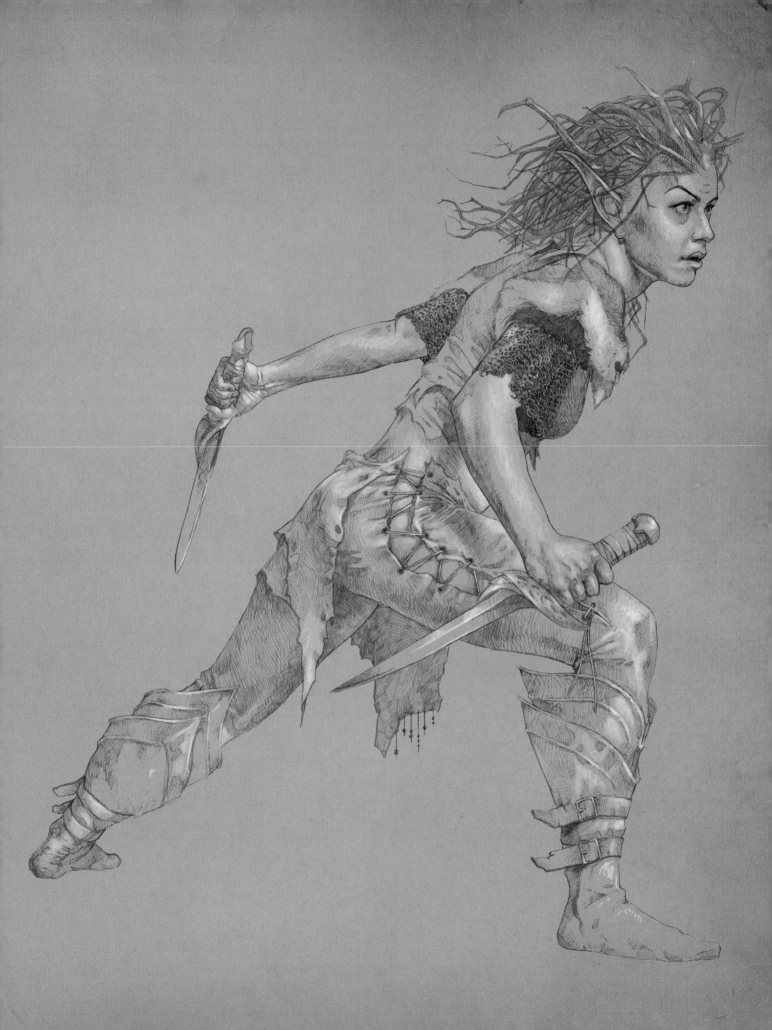

# PIRATE PRINCESS

The most important thing when developing the clothing for a fantasy character is to make sure it helps tell the character's story in a believable way. The goal in drawing your character's clothing is to make them look like they are really from another time or place, and not just a person playing dress up. In the real world, people frequently dress in layers. For example, a businessman might wear a dress shirt, a tie, a sport coat and a belt. Use the same approach when designing fantastic costuming to add multiple layers and details. Consider less visible clothing and undergarments such as padding under armor, or the shirt under a tunic.

Accessories like jewelry, belts and hats can further develop the character. Embroidered symbols, buttons, stitching, fur textures, leather tooling, lace, metals, gems and even wooden decorative details such as fine beads can accentuate a garment or accessory. Explore lots of variations before settling on what to render in the final drawing. Take the time to consider different hats, hairstyles and coats to find what will look best for your character and add the greatest depth and believability. Museums and books/magazines on modern fashion are fantastic places to look for inspiration as well.

### The Story
"Alvida knew she had made the right choice the first time she saw the docks. She was never meant to be an ornament for some arrogant prince, stuck in a stuffy tower. She was meant to be a privateer! And she knew that today was going to be the first day of her new life ..."

### The Pose
Whenever you are using a reference for costume design, you want to kept the pose fairly simple to help you communicate as much as possible about the costuming. Adding a bit of a weight shift or tilting the head is okay to keep the pose from looking stiff like a mannequin. Just be careful not to add too much action, since that can make it difficult to see the entire costume.

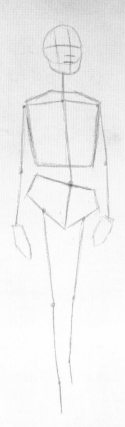

**1** **Sketch the Basic Pose**
Draw simple lines to create the basic stick form. Make sure to depict the shift of weight in the hips so the final pose doesn't appear too stiff.

**2** **Outline the Pose**
Add the basic outline to the form and remove some of the stick lines to simplify the drawing for later.

**3** **Outline the Shadows**
Finish removing all of the stick lines; add guides for the shadows and highlights according to the reference.

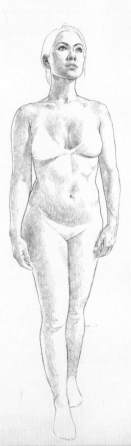

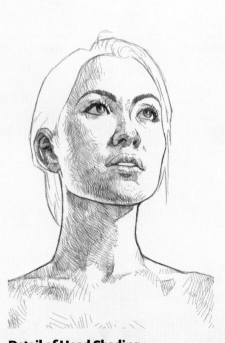

**4** **Shade the Face and Body**
Begin shading the face and torso. Keep everything but the hands and face really light since most of it will be removed when you add the clothing. Continue to shade in the rest of the figure.

**Detail of Head Shading**

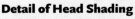

### 5 Block In and Shade the Clothing

Add the basic form for the clothing. Take time to match the clothing to the form of the drawing so it appears natural rather than just copying the reference exactly. Notice the multiple layers in the reference photo, especially the belt. Try to put in as much detail as possible when shooting clothing reference so you don't have to guess how things look, like how the cloth looks tucked into a belt. Add shading to the clothing using the reference to decide what to make darker or lighter. While shading in the cloth, think about adding small details to embellish the costuming such as lace on the cuffs and a collar on the shirt.

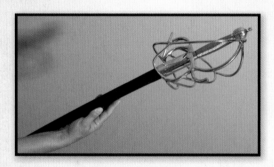

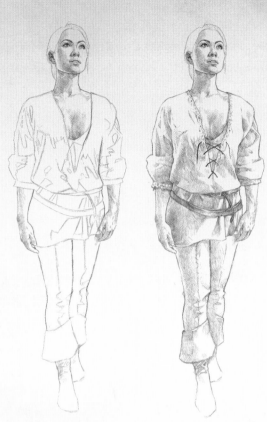

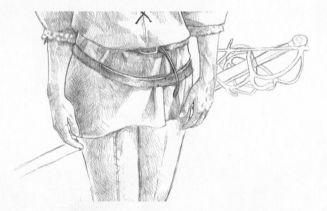

### 6 Block In and Shade the Sword

Block in the basic shape of the rapier. This is a very complex form so go slowly and look closely at the reference. If it's too difficult, simplify the form to a more basic sword. Add shading to the sword and small details to the metal such as engravings or gems.

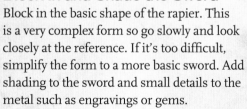

### Exploring Hats and Hairstyles

How many times have you looked at a drawing after it was finished and said, "DOH! Now I know what I should have done."? This happens to every artist at some point. This is usually because we didn't take the time to explore all the various options before we sat down to draw. When designing clothing for a character, take the time to try different looks. These explorations don't need to be highly detailed with beads and stitching; simple thumbnail sketches will do so you can examine the basic forms. Here we try out various combinations of three hats and three hairstyles on our model.

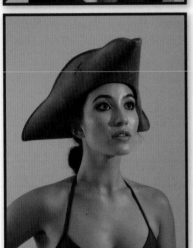

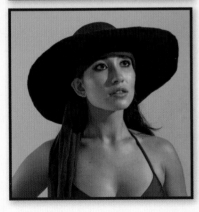

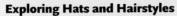

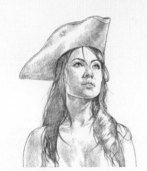

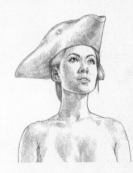

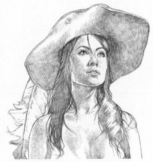

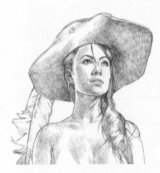

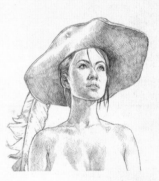

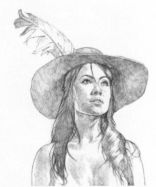

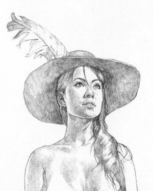

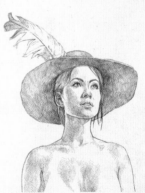

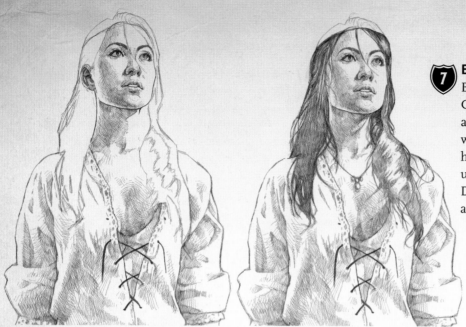

### 7 Block In and Shade the Hair

Block in the basic shapes for the hair. Consider different hairstyles such as pulled back or let down to decide what fits your story best. Shade in the hair. Remember not to draw individual hairs but large chunks of values. During the shading I also decided to add a necklace to match her outfit.

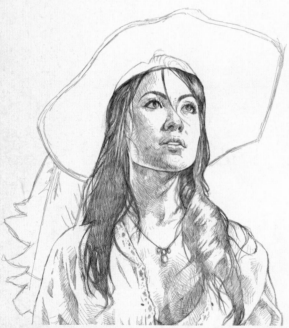

### 8 Block In and Shade the Hat

Block in the basic form of the hat. I've chosen to draw a combination of a colonial and tricorn hat but feel free to use either one. Shade the hat and add some decorative beading.

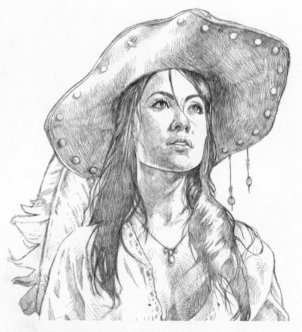

### 9 Finishing Touches

Continue to refine the image to make it your own. I've depicted this pirate princess wearing a corset and a shoulderless shirt.

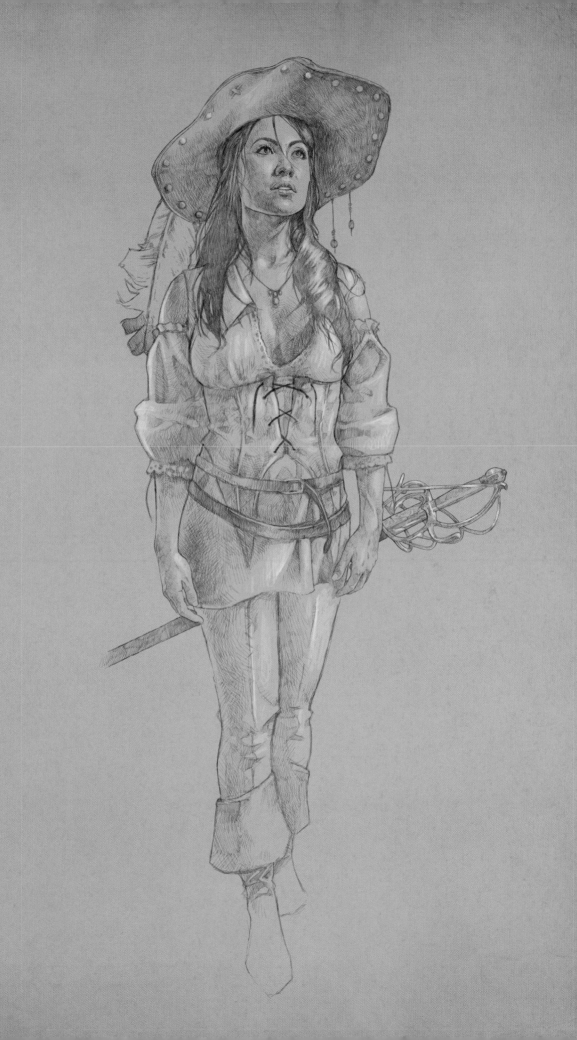

# MAGICAL DAGGER

From Excalibur to Mjolnir, myths and legends are full of fantastic weapons. As a fantasy artist, it's helpful to be able to design weapons that are just as unique as the characters that use them. Every fantasy artist would love to have a full complement of props at their disposal. Imagine how easy it would be to create fantastic weapons if we had a ton of swords, knives and armor to choose from. Although prices of theatrical swords and other weapons are very reasonable, having more than a few is not practical for most of us. Some props and theatrical weapons can also have a tendency to look like toys. This makes it important to be able go beyond the basic prop and use your imagination to create unique yet believable weapons.

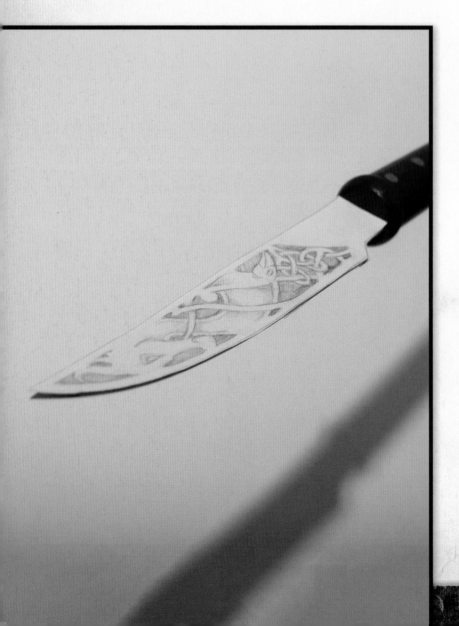

### The Story
"The blade wasn't very long, maybe five or six inches is all, but the ornate etching on that blade made it clear this was no ordinary hunting knife ..."

### The Design
To create the reference for this dagger, I started with a knife that came with a set of grill tools. I wanted to create unique etchings on the blade so for inspiration I looked at old Viking art from the Urnes Stave Church in Norway. The church contains some fantastic wood carvings that are highly detailed. When adding embellishment to fantastic weapons I have found it helpful to look at elements other than weaponry such as architecture and sculpture.

Once I settled on a design, I drew it on a piece of paper then cut it out and taped it to the blade of the grill tool. This allowed me to see how the etching would act with perspective added to it. This is a great technique to use whenever trying to add carvings or paintings to a surface, especially when the surface is in perspective or curved.

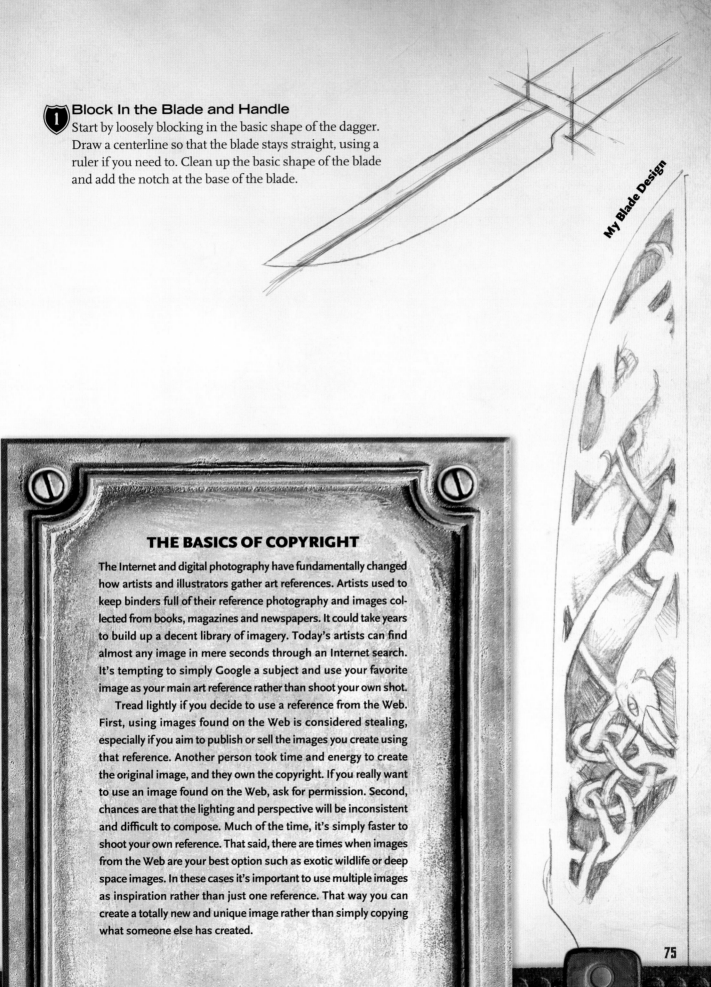

### ① Block In the Blade and Handle

Start by loosely blocking in the basic shape of the dagger. Draw a centerline so that the blade stays straight, using a ruler if you need to. Clean up the basic shape of the blade and add the notch at the base of the blade.

**My Blade Design**

## THE BASICS OF COPYRIGHT

The Internet and digital photography have fundamentally changed how artists and illustrators gather art references. Artists used to keep binders full of their reference photography and images collected from books, magazines and newspapers. It could take years to build up a decent library of imagery. Today's artists can find almost any image in mere seconds through an Internet search. It's tempting to simply Google a subject and use your favorite image as your main art reference rather than shoot your own shot.

Tread lightly if you decide to use a reference from the Web. First, using images found on the Web is considered stealing, especially if you aim to publish or sell the images you create using that reference. Another person took time and energy to create the original image, and they own the copyright. If you really want to use an image found on the Web, ask for permission. Second, chances are that the lighting and perspective will be inconsistent and difficult to compose. Much of the time, it's simply faster to shoot your own reference. That said, there are times when images from the Web are your best option such as exotic wildlife or deep space images. In these cases it's important to use multiple images as inspiration rather than just one reference. That way you can create a totally new and unique image rather than simply copying what someone else has created.

75

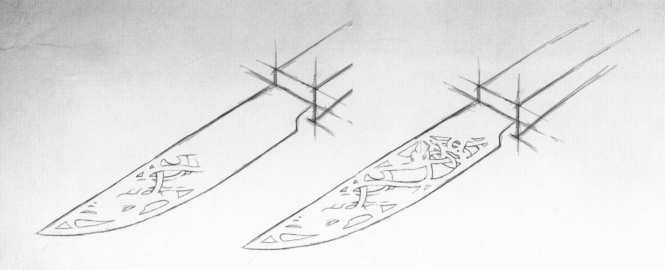

## ② Sketch the Blade Etching

Draw in the basic shapes for the etching on the blade. Use the reference to see how it changes in perspective, it's important that the etching looks truly carved on the blade.

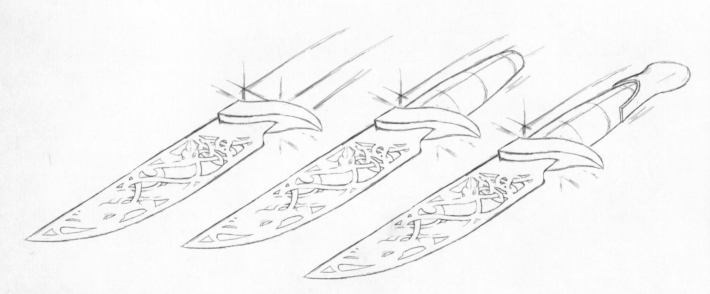

## ③ Refine the Handle

Block in the handle and its details. Pay close attention to the elliptical shape of the handle so the hilt and pommel don't get too flat. Block in the basic shape for the hilt. At this stage keep it a basic form to make sure the perspective is correct.

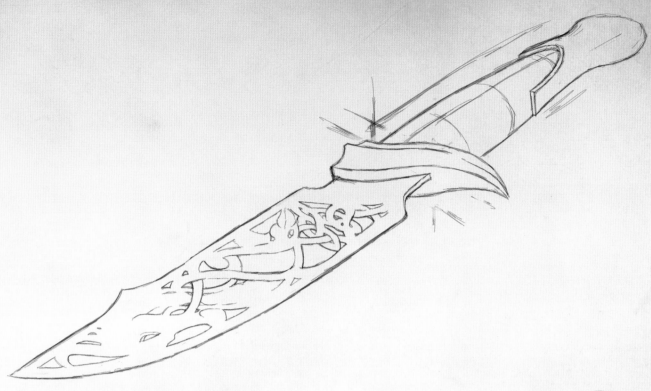

### 4 Adjust the Blade and Hilt Shape
Add some extra details to the shape of the blade and the hilt. This will keep it from looking too much like a basic hunting knife and more like an ornate dagger.

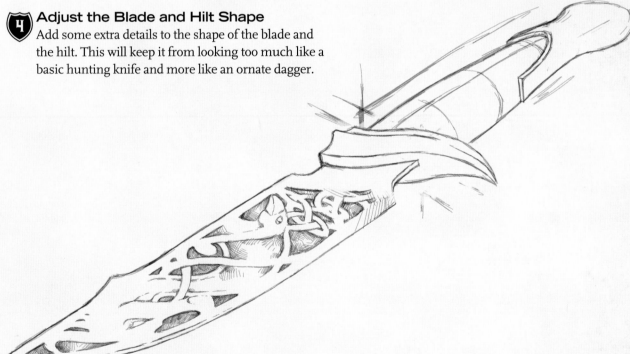

### 5 Shade the Blade Etching
Begin to add shading to the etching on the blade. Darken around the edges of the etching and then lighten up away from the edge. If you get it too dark, it will look like holes in the dagger and not an etching in the blade.

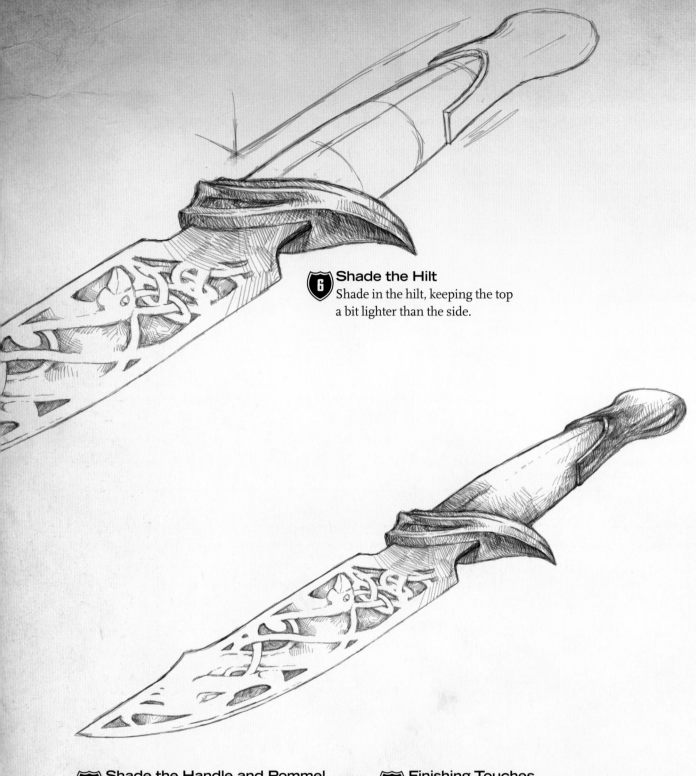

### 6  Shade the Hilt
Shade in the hilt, keeping the top
a bit lighter than the side.

### 7  Shade the Handle and Pommel
Finish the drawing by shading in the
handle and the pommel.

### 8  Finishing Touches
Add some highlights onto the blade, hilt and
pommel to make sure it looks like metal.

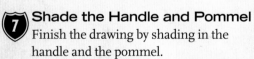

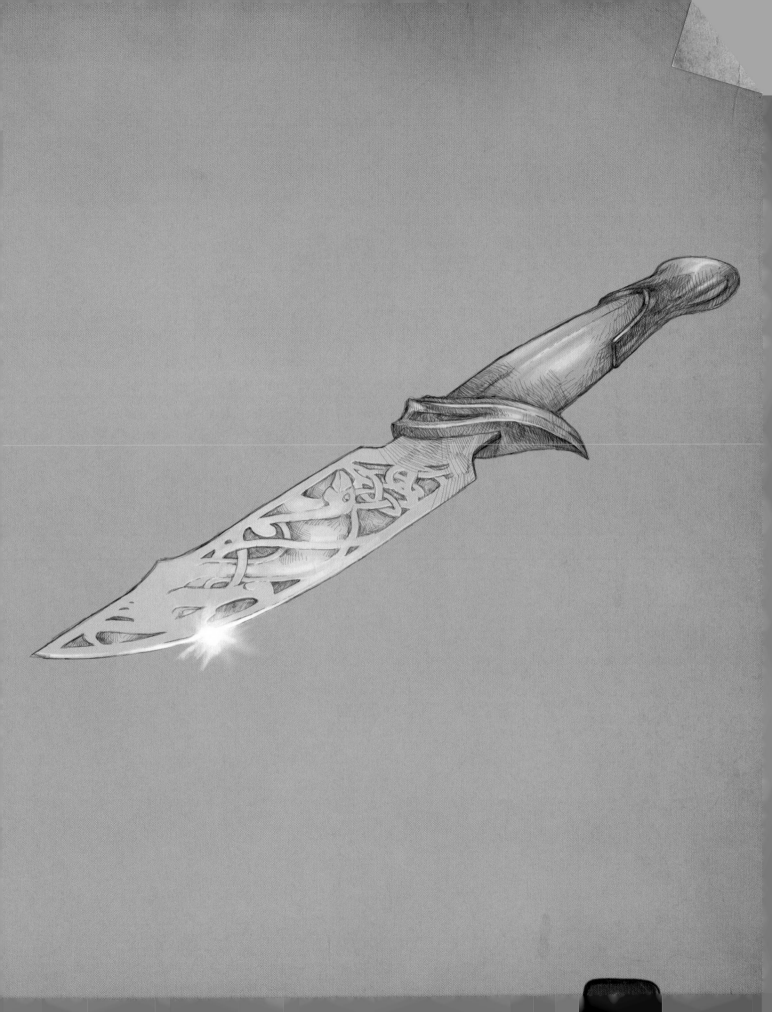

# WIZARD'S TOWER

When trying to create a believable fantasy environment, it is helpful to look at the world around us for inspiration. For example, you could combine a tree with tropical flowers that don't naturally grow on it to create a tree that is strange and alien to the eye. Both the flowers and tree exist in the real world, but putting them together in an unexpected way makes the scenery fantastical.

Scale models, such as toy railroading supplies, are also helpful for building scenes to test potential light and shadows. Set up your model scenes and photograph them in different lighting situations to get a sense of how the light is going to react in that environment.

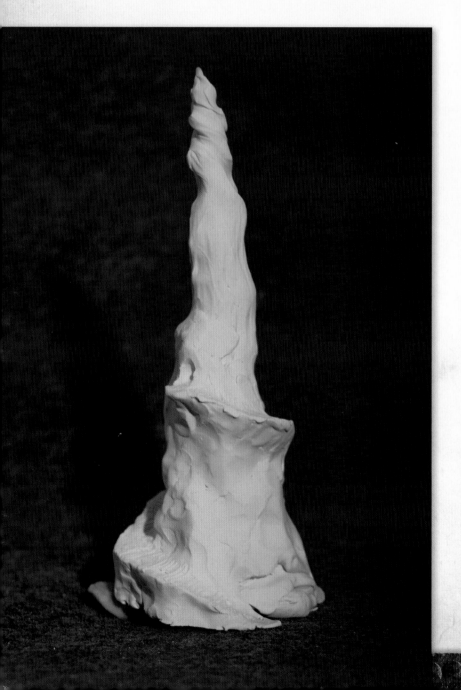

### The Story

"No one really knows when Adian's tower appeared or who built it. Some old villagers believe it's been there since the beginning of time. Even more of a mystery than when it appeared is what lies inside the great tower. Many have taken the winding stairs to the stone door only to find it locked with no way to open it ..."

### Clay Structure

Modeling clay can be extremely helpful for rendering fantasy structures. My son and I constructed this tower in a couple of hours one evening out of simple modeling clay from a craft store. This saved tons of time while drawing because I didn't have to imagine the lighting, shadows and perspective.

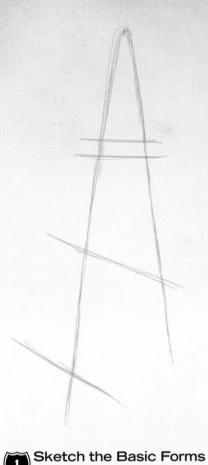

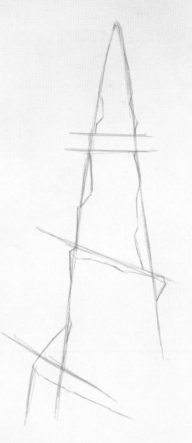

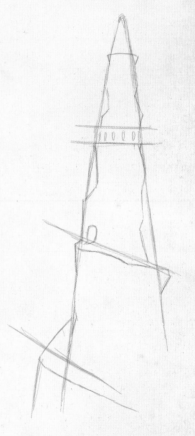

### 1 Sketch the Basic Forms

When working with architecture or any man-made structure, it's important to start with the basic geometric forms. Keep the form basic and simple so you can make sure all the lines are in the right place.

### 2 Refine the Shapes

Refine the outside form and shapes for the winding stairs.

### 3 Add the Door and Windows

Add the shapes for the door and the window.

 ## 4 Block In the Shadows

Looking closely at the reference, block in the shapes for the shadows. Remember to remove the guidelines as you go.

## PRACTICE DRAWING FROM LIFE

One of the drawbacks of working from photographic reference is that the lens can distort the image and the subject's proportions. Though your subject may look fine in the photograph, if drawn realistically it may look strange or distorted. That's why it's important to practice drawing from life whenever possible. It will help you develop a practiced sense of the differences between photographs and reality. In a photo, a hand that's closer to the lens might appear disproportionately large. This will not be the case when viewed in real life.

Take time to practice drawing from life. An afternoon of plein air painting or a life drawing session will help sharpen your most basic drawing skills. Shortcuts like gridding and tracing are helpful, but if you don't keep up your drawing skills by regularly drawing from life, the quality of your art will suffer.

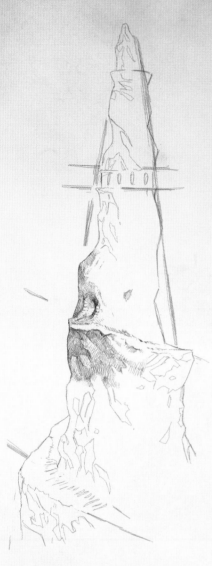

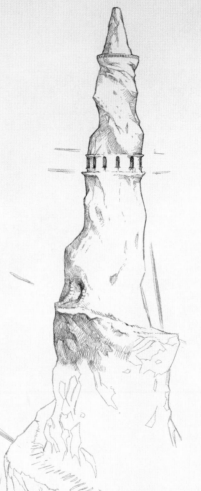

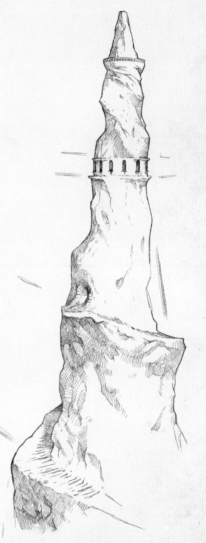

**5 Begin Shading the Tower**
Begin to shade in the tower. Use variety in the shadows to help add a sense of depth to the form.

**6 Continue Shading and Add Details**
Continue shading in the forms and add little details such as arrow slits on the top balcony.

**7 Complete the Shading and Define the Stairs**
Finish the shading and the stairs. Simply implying the stairs is enough; you don't need to draw each individual step. Like drawing hair, less is more.

**Referencing Trees**

When working with landscapes it's important that you have a sense of scale of whatever you are drawing. An easy trick is to include something that has a defined size in the image. By adding simple trees to the drawing, the tower goes from a clay model to a giant tower looming in a forest.

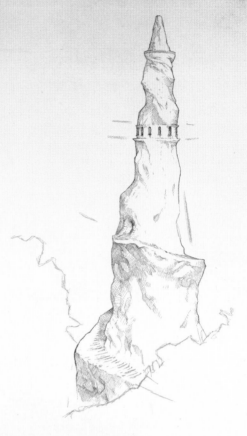

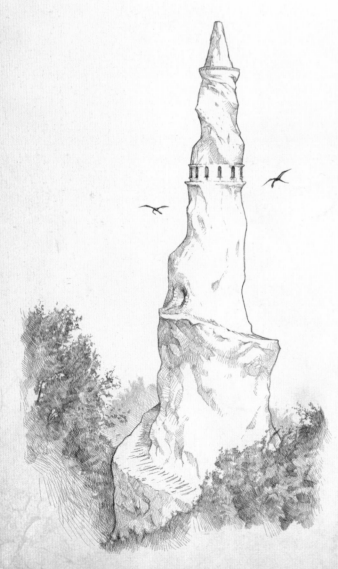

**8** **Block In the Trees**
Start by blocking in the shape of the trees. Make sure to place one set in front of the tower and one set in back to define the size of the tower in relationship to the trees around it.

**9** **Shade the Trees**
Shade in the trees. Imply leaves and branch shapes without drawing individual leaves.

**10** **Finishing Touches**
Add extra elements to make it even more fantastic, like dragons flying around the tower and a few more bushes in the distant background. Don't be afraid to be creative in making this your own image. Just keep it simple.

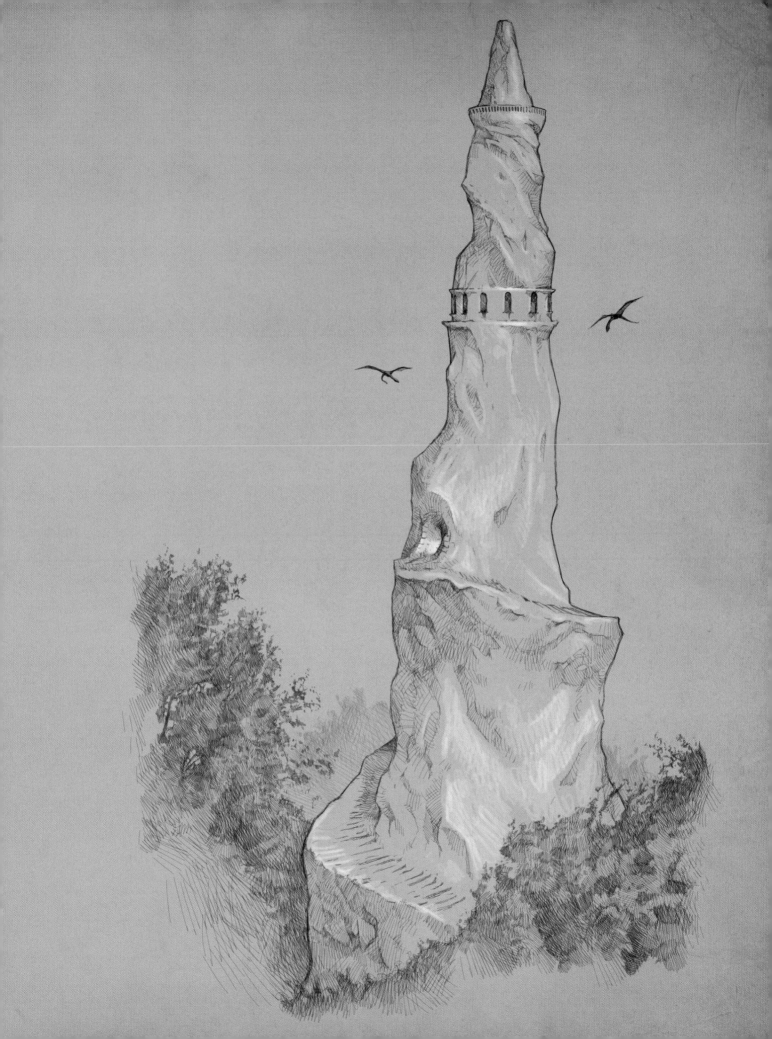

# DRAGON

Dragons are one of the most iconic fantasy creatures, and most fantasy artists love to draw them. From ancient Chinese dragons to medieval dragons to modern dragons, hundreds upon hundreds of variations help make them so fun to draw. Although dragons are not real, most people can easily identify a dragon when they see one.

When drawing dragons, use the right visual cues so your drawing is perceived as a fantasy creature instead of a lizard or dinosaur. These visual cues are based on certain parts of animals that do exist on earth but usually not together on the same creature. Visual cues such as wings, scales, an elongated nose, sharp teeth and mean eyes can be arranged in ways that help our minds register the creature as a dragon.

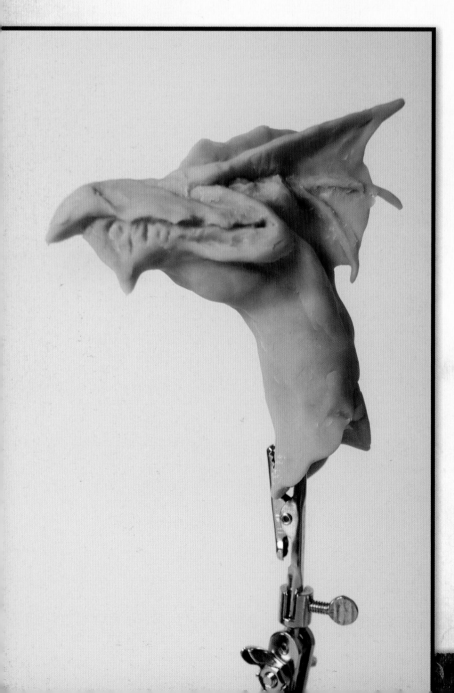

### The Story
"No one had seen the great wrym for hundreds of years; some even doubted that it existed. Ronan knew better, and he knew the evil beast was in the cave somewhere. Suddenly he heard the slithering of scales behind him. He spun just in time to see a giant dragon's head emerging from the shadows ..."

### The Pose
Since dragons are not real creatures, modeling clay can be a fantastic help. A simple maquette such as this one can help show the basic shapes and values of the form. For inspiration I did a simple internet search for dragon images to make sure my sculpture captured a classic dragon look. I made sure to use four or five different images to avoid referencing one image too closely.

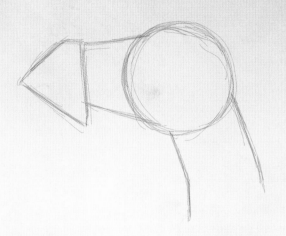

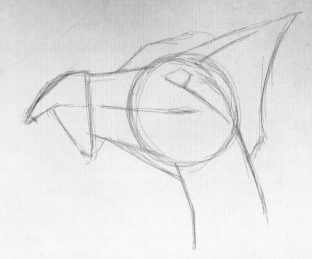

## ① Sketch the Basic Forms
Start with the basic geometric forms of the head. Use basic geometric shapes to see the form more clearly and not get too focused on details.

## ② Block In the Facial Features
Block in the mouth, eye and ear, still keeping the shapes very basic.

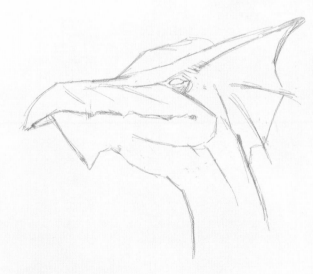

## ③ Refine the Shapes
Using the clay model as a guide, continue to refine the shapes, slowly adding more details and erasing your sketch lines as you go.

### WORKING WITH CLAY

Being able to sculpt is a wonderful skill for any fantasy artist or illustrator. You don't have to be a great sculptor, but taking the time to learn how to sculpt, at least a little bit, can be very helpful. Sometimes you need to reference figures that can't be easily accessed. The ability to sculpt a likeness helps you create a model that can be used to see how light and shadow fall on that shape. The ability to sculpt a 3-D image of what you have in your mind can make drawing it much easier. A number of comic book artists and illustrators use sculpting clay to create heads or faces as references to work from. Some types of clay even mimic skin and the way light passes through skin. Even the ability to sculpt a rough form from a kneaded eraser can allow you to see how light and shadow will fall around and on that form.

## ANIMAL REFERENCE

Even though dragons are magical creatures comprised of a unique set of features, many of those features are based on real-life animals. The most obvious element of a dragon is the scales. Scales behave differently than skin or fur and studying the scales of snakes can help you make your dragons more believable.

The eyes and the areas around the eyes are also an important dragon feature. Lizards and snakes have many different shapes of eyes and are a wonderful source of inspiration for adding unique elements to your dragons. Remember, even though fantasy creatures such as dragons and unicorns are not real, they are made up of bits and pieces from real animals. Using real animals as a reference is an important part of the drawing process that will help your fantasy creatures come to life.

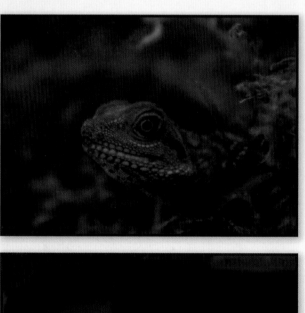

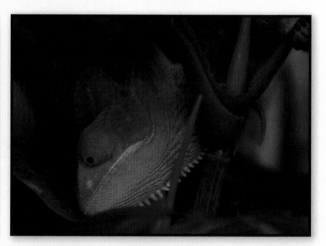

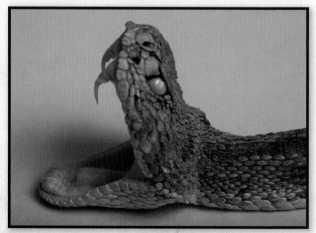

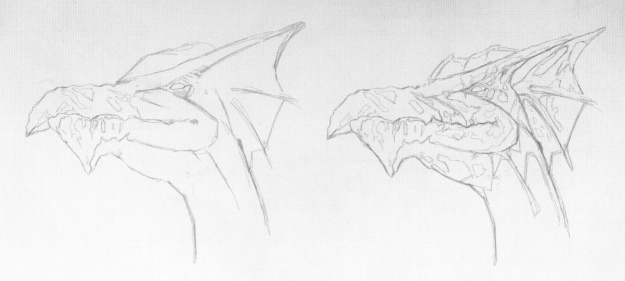

### 4 Block In the Shadow and Highlight Areas
Block in the shadows for the dragon's face. Also refine the neck and ears to add a bit more detail.

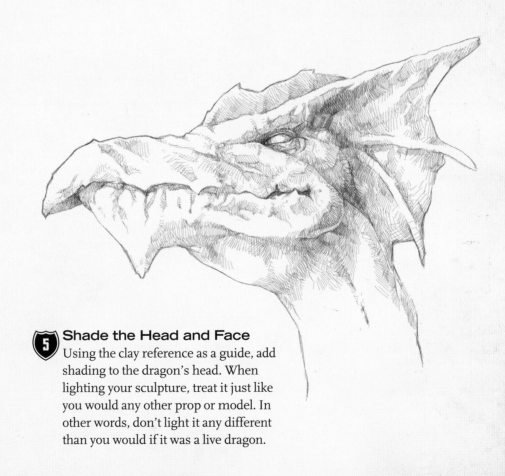

### 5 Shade the Head and Face
Using the clay reference as a guide, add shading to the dragon's head. When lighting your sculpture, treat it just like you would any other prop or model. In other words, don't light it any different than you would if it was a live dragon.

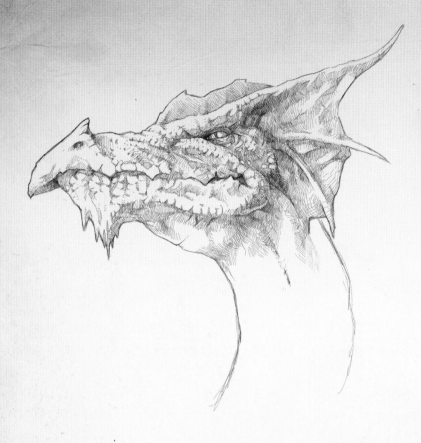

### 6 Define the Snout

Add a more pronounced tip to the snout and then add scales. Scales should be kept simple, so do not draw all of them. Add the scales to the rest of the face and put pupils in the eyes. Then add some spikes to the ear to make him more dragon-like.

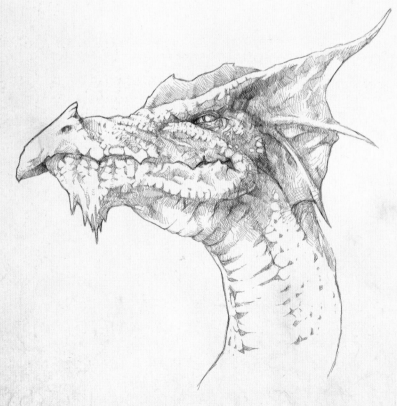

### 7 Complete the Neck

Draw in the rest of the neck, keeping the scales fairly simple.

### 8 Finishing Touches

Create a dark outline around the dragon's main forms.

Visit impact-books.com/fantasyreference to download a free bonus art gallery

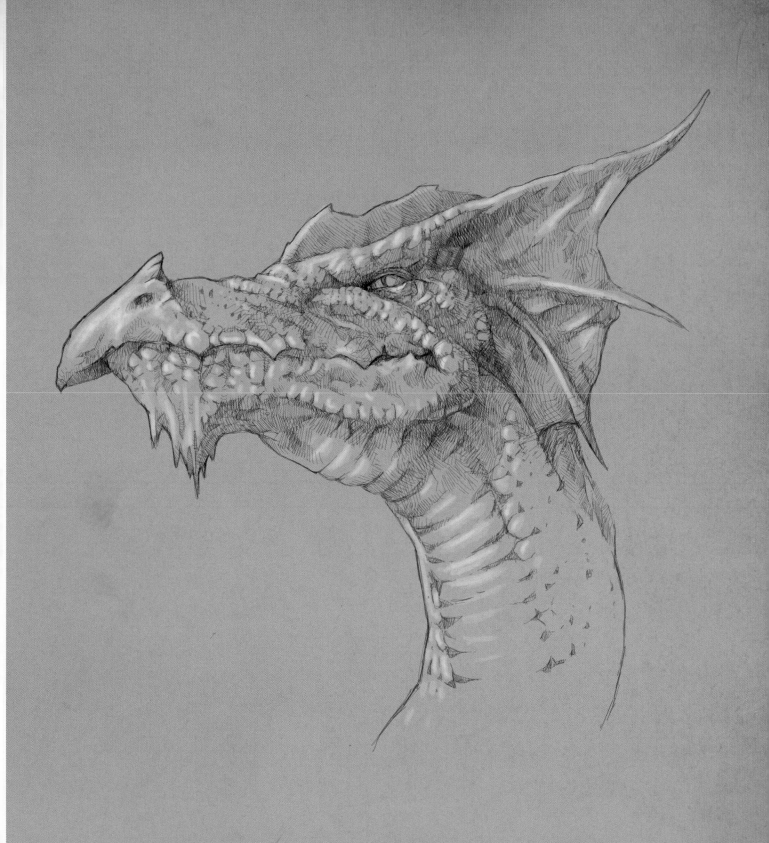

# UNICORN

Some magical creatures, like unicorns and Pegasus, are not much different than creatures in the real world. When dealing with these types of creatures, draw the real-life animal first and add the fantasy aspects afterward. The unicorn and Pegasus are based on the forms of an everyday horse with an added horn or wings. The horse and horn are based on real animal features, and the artist must follow the rules that exist for that creature in real life. If the horse is drawn poorly at the start, it won't matter what fantasy aspects are added, it just won't look right.

Photographing an animal reference is a lot different than photographing a person. Animals do not pose in just the right spot or angle. It is also difficult to control the lighting in the same way we might for a human or sculpted model. It's a lot like photographing children. You just have to stay put and continuously click and check through the viewfinder until you see the image you want. When working with animals, take lots and lots of pictures. If you start out with a preconceived idea of how you need the animal to position itself or behave, you will most likely be disappointed. Instead, look at the images after you have taken them, and find the most natural poses to create the desired fantastic image.

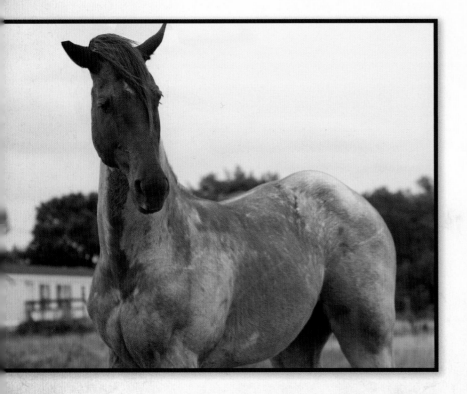

### The Story

"Ellaina, the young elfin maiden, stepped into the clearing and gasped. Standing tall and proud in a field of waist high grass was a... unicorn. Never before had she seen such beauty and grace. The creature's head turned and its eyes met hers. In that moment she could hear the unicorn's thoughts in her mind as clearly as if it was speaking aloud ..."

### The Pose

The Heath family allowed me to come out to their ranch and spend a couple of hours photographing the horses. I was able to capture some fantastic references that would have been difficult to get otherwise. For the final image I combined two different horses to get the energy I wanted. I also flipped the final composition so that the horse looks to the right. This was simply a personal aesthetic choice as I generally prefer to have my subject looking left to right.

Visit impact-books.com/fantasyreference to download a free bonus art gallery

## 1 Sketch the Head Shapes
Start by defining the basic shape of the head, a large oval for the jaw and forehead area, then smaller circles for the muzzle and nose. Don't forget to add the centerline.

## 2 Sketch the Body Shapes
Continue to define the form by adding a large oval for the torso and lines to indicate the neck and back.

## 3 Define the Head Features
Further define the shape of the head and neck, and add shapes for the ears.

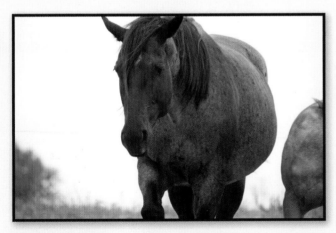
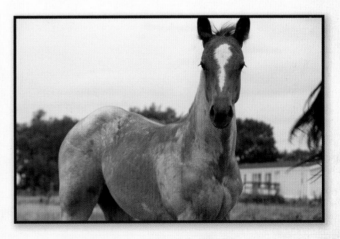

**Horse References**
The horses had a bit of a mind of their own during the photo shoot. Although there were many great images, there wasn't a perfect shot to draw from. So my solution was to flip the images and combine the head and body into the reference used in this section (see facing page).

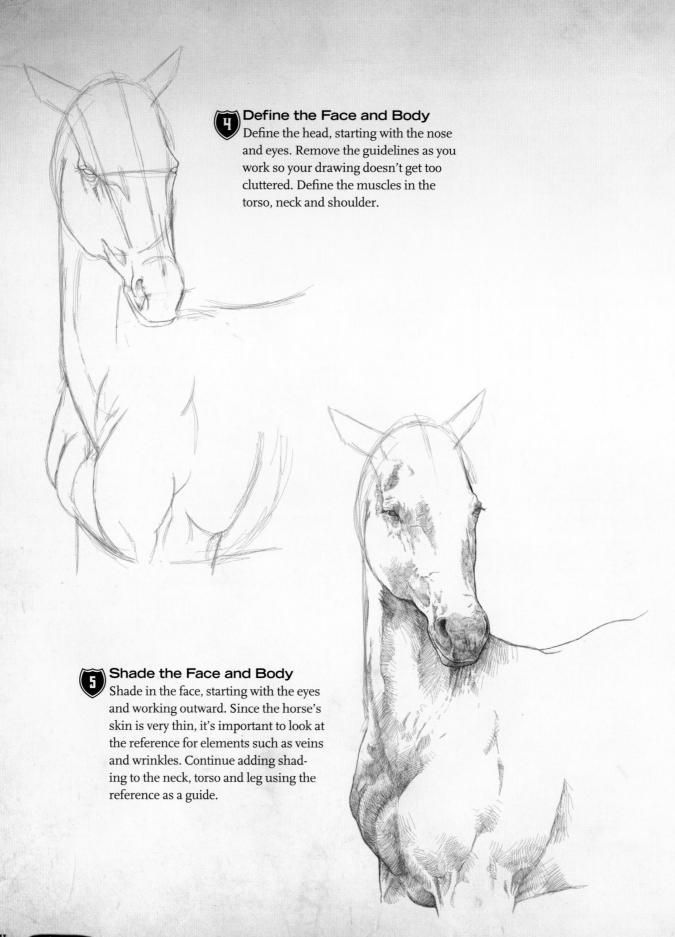

### 4 Define the Face and Body
Define the head, starting with the nose and eyes. Remove the guidelines as you work so your drawing doesn't get too cluttered. Define the muscles in the torso, neck and shoulder.

### 5 Shade the Face and Body
Shade in the face, starting with the eyes and working outward. Since the horse's skin is very thin, it's important to look at the reference for elements such as veins and wrinkles. Continue adding shading to the neck, torso and leg using the reference as a guide.

## 6 Shade the Ears
Shade the ears adding a variation in the values so they don't appear too flat rising out of his head.

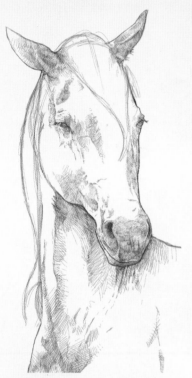

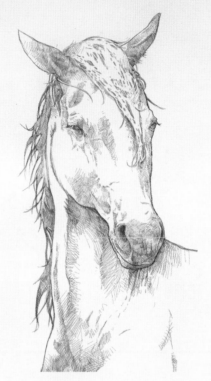

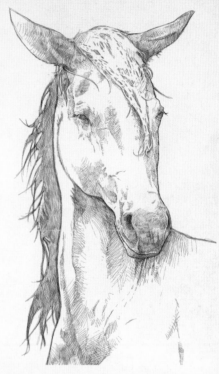

## 7 Block In the Mane
Block in the basic shapes for the mane down his neck and forehead.

## 8 Shade the Mane
Add the shading for the mane, keeping the left half darker to define the neck.

## 9 Elongate the Mane and Ears
Unicorns should have a bit of a wild look to them. So if your image looks too domesticated, add a longer mane and bigger ears. Don't make the ears too large or he might end up looking like a donkey.

## COLLECT COOL STUFF!

Every fantasy illustrator needs a collection of unique objects for fantasy reference. Try to collect as many odds and ends as possible, keeping an open mind to the potential an object might have. You never know when animal bones, fur, pieces of metal, pieces of leather, clothes or hats will come in handy. If you are on a tight budget try to hit the after Halloween sales for a good deal. Renaissance fairs, garage sales and the Internet are great places to find things. Even swords have become very inexpensive to purchase over the Internet. Something that might, at first glance, seem like junk to throw away could become a reference when looked at the right way through the eyes of an artist. For example, the way light reflects off a Christmas ornament could give you a reference for how light might reflect off that color of armor.

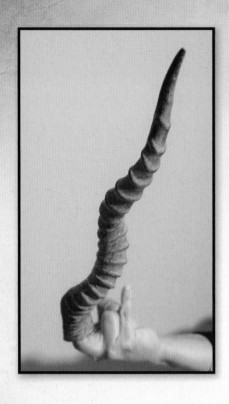

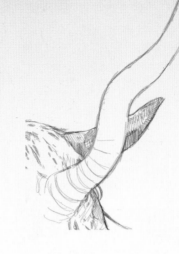

### ⑩ Block In the Horn

Create a simple shape to block in the basic form. Adjust the mane as needed where the horn attaches to the head.

There are many approaches to a unicorn's horn, but the most successful and believable variations tend to be horns that are based on real animal horns. This horn image is from a black buck antelope.

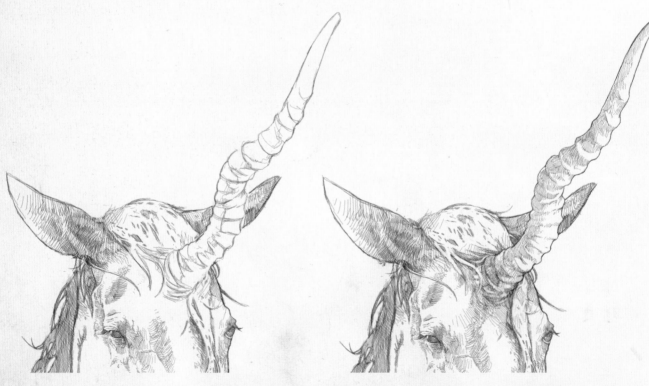

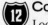

### ⑪ Refine the Horn

Since this horn is such a complex form, add another level of refinement to the shape and begin defining the areas of shadow.

### ⑫ Complete the Horn's Shading

Looking closely at the reference, finish the shading in the horn. Notice the darkest areas are where it attaches to the head.

Visit impact-books.com/fantasyreference to download a free bonus art gallery

## CREATING FEMALE CHARACTERS
# SEDUCTIVE VAMPIRE

Seductive women and fantasy art go together like peanut butter and jelly. From Reynold Brown's movie posters to Frank Frazetta's book covers, women have always played an important part in the fantasy genre. And over the last thirty years, the roles women play have become more and more powerful. Gone are the days where the woman in a painting was a damsel in distress waiting to be rescued. In contemporary fantasy and sci-fi culture women are just as likely to be the ones rescuing the men. When creating your fantasy art you should take this into account. There is nothing wrong with adding a little bit of sexy and seductiveness to the women in your art; however, try to add a bit of power and sophistication as well. Not only will this appeal to wider audiences, it will also create more depth in the subject matter.

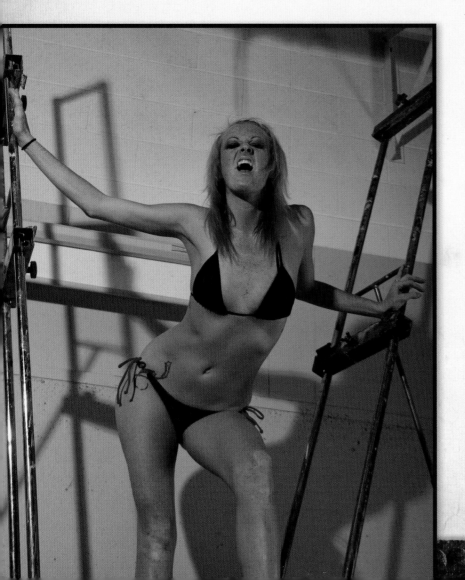

### The Story
"Once the pinnacle of the noble class, Aryanna now ruled the night. With her long, flowing red hair and beautiful features, she had no trouble luring young men into her web. Unfortunately for these poor souls, she saw them as nothing more than a feast to dine upon ..."

### The Pose
I wanted my model to pose seductively but also clearly depict a vicious vampire. To accomplish this, I asked her to lean forward with her mouth open to help draw attention to the fangs. The shift in the hips helps to add action as well as an alluring aspect to the pose.

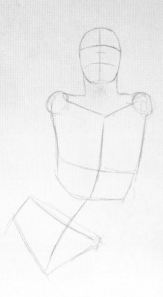

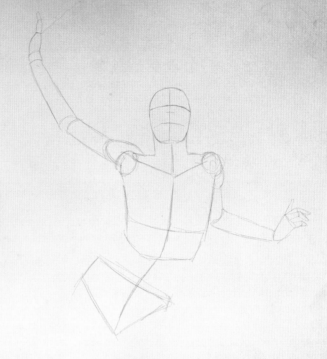

### Block In the Basic Shape

Block in the basic face shape indicating simple guidelines for the eyes, nose and mouth. Since the head is turned up, be sure to look closely at the photo for placement of those guidelines. Keep your lines very light in the early steps. Indicate the spine with a curved line. Be very accurate with this line since it adds motion to the pose. Block in the shoulders, torso and hips.

### Block In the Arms

Using simple cylinders, block in the arms. Note that I adjusted the angle of her right arm a bit compared to the reference. Use your creative license to get the pose you desire.

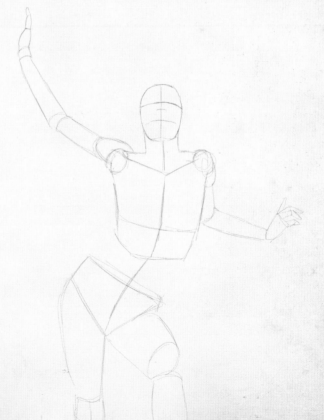

### Block In the Legs and Knees

Continue using basic shapes to block in the legs, carefully matching both knees to the reference pose.

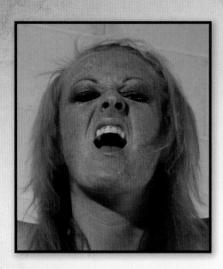

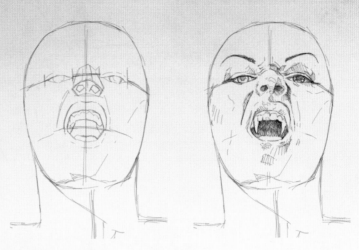

### 4 Block In and Shade the Face
Block in the contours of the face. Pay close attention to the shape of the nose to depict her snarl and sharp teeth. Shade the face, paying extra attention to the planes of the nose.

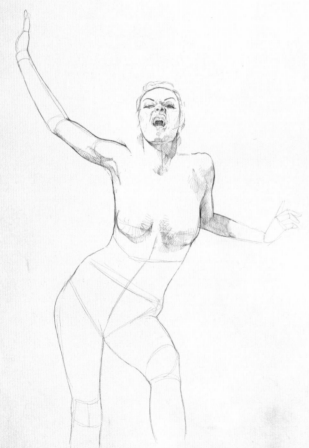

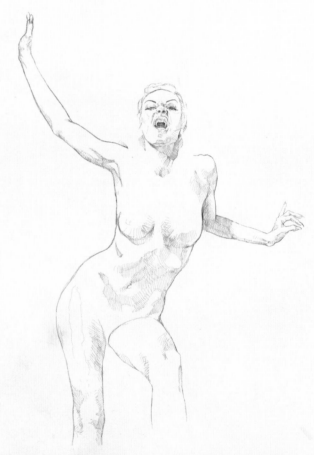

### 5 Outline the Body and Shade the Arms
Define the contours of the body, slightly exaggerating the hips to add more movement to the pose. Shade the neck and shoulders removing guidelines as you go.

### 6 Shade the Arms, Hands, Torso and Legs
Define and shade the arms, hands and stomach. Don't forget to add the highlight on the right lower rib cage and the right hip. These elements are critical to adding energy to the pose. Finish the shading on the legs. Since most of the legs will be covered, don't spend a ton of time on this area.

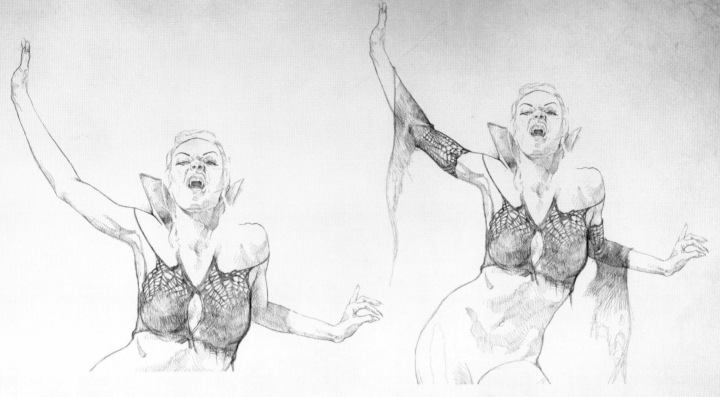

### 7 Add the Clothing

Add the upper part of the dress and a turned-up collar. Always make sure the clothing reflects the personality of your character. Since we are depicting a bloodsucking vampire, a spiderweb works well with the evil theme.

### 8 Add the Sleeves

Add the sleeves, continuing with the spiderweb pattern.

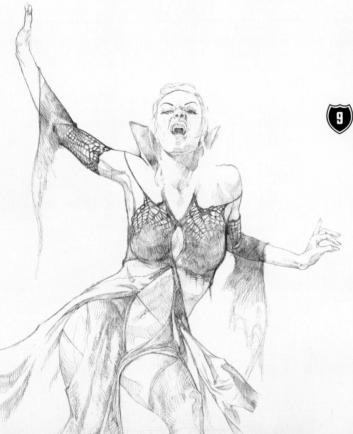

### 9 Complete the Dress

Finish the clothing by adding a flaring dress. If you struggle to get the cloth folds and shadows right, create a quick reference photo to help find the shapes and shadows.

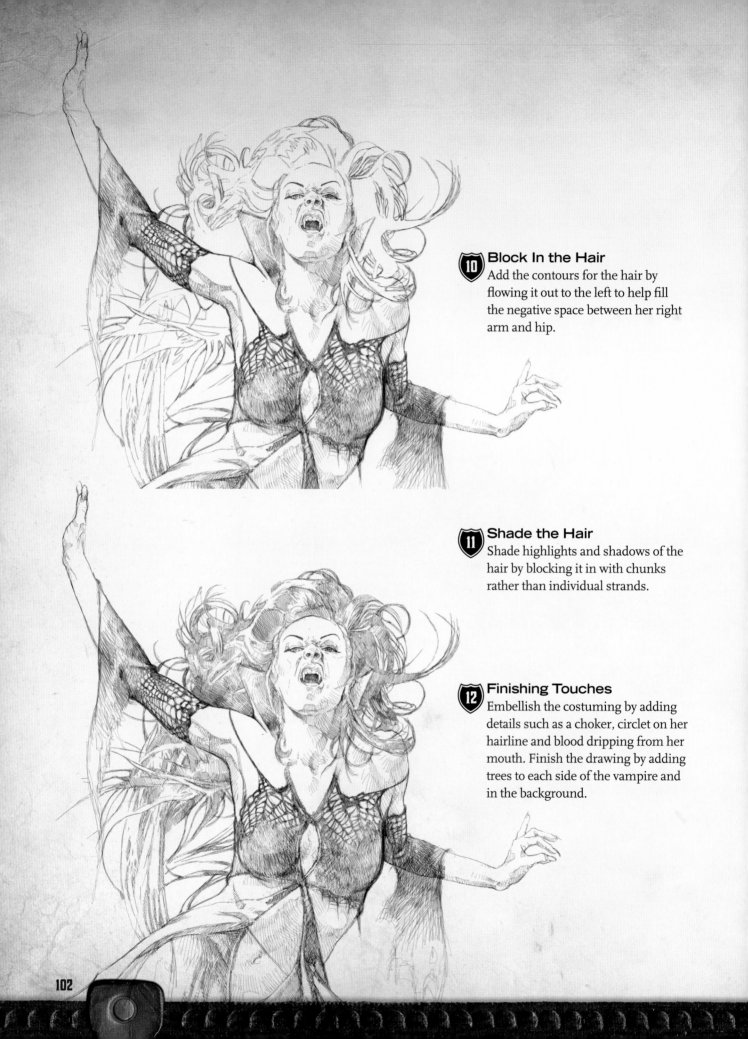

### 🛡10 Block In the Hair
Add the contours for the hair by flowing it out to the left to help fill the negative space between her right arm and hip.

### 🛡11 Shade the Hair
Shade highlights and shadows of the hair by blocking it in with chunks rather than individual strands.

### 🛡12 Finishing Touches
Embellish the costuming by adding details such as a choker, circlet on her hairline and blood dripping from her mouth. Finish the drawing by adding trees to each side of the vampire and in the background.

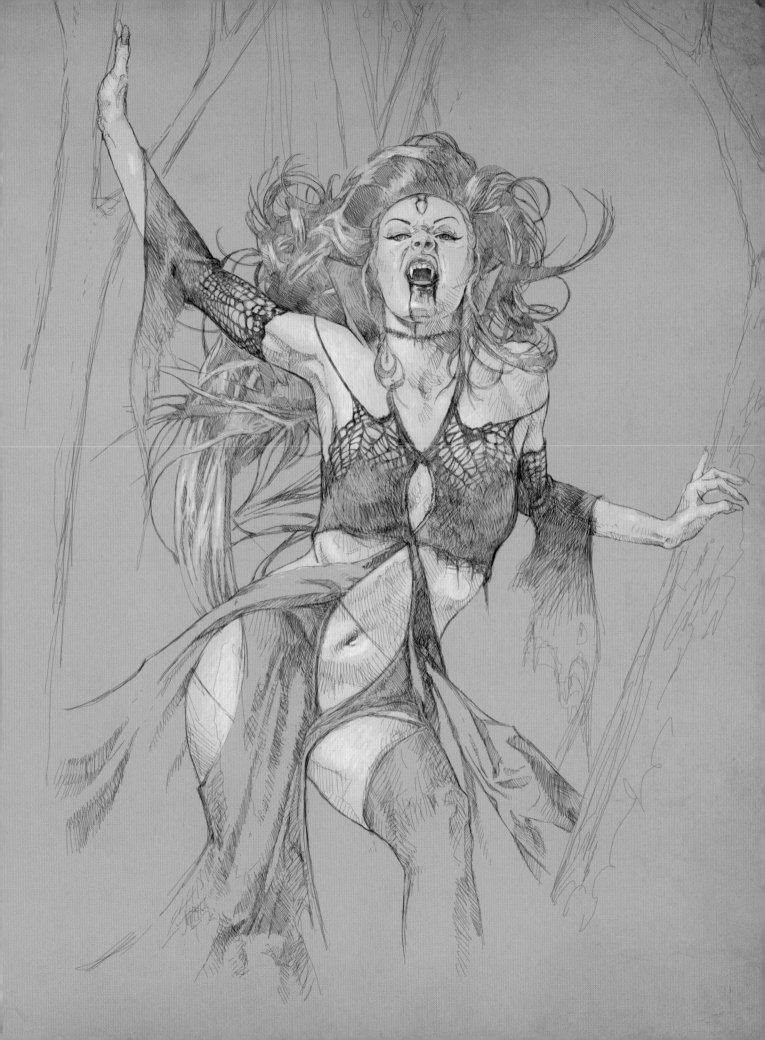

## BRINGING FANTASY TO LIFE

# MAIDEN OF THE FOREST

When creating fantasy drawings like Ents, constructs and other monsters, it can be effective to incorporate human elements into the design. As humans we show emotion through facial expressions with our eyes, eyebrows, nose and mouth. Including basic human features is fundamental in allowing our fantasy characters to communicate an emotion. This method appears in animated cartoons, whether it's a talking mouse, fish or gumball machine. Study your photo references of humans for places you might place nonhuman elements to create interesting, expressive fantasy characters.

Even though the skin in this demonstration is made of bark and the hair is made of branches, it's important to use the photo reference as a guide for the directions and values of those textures.

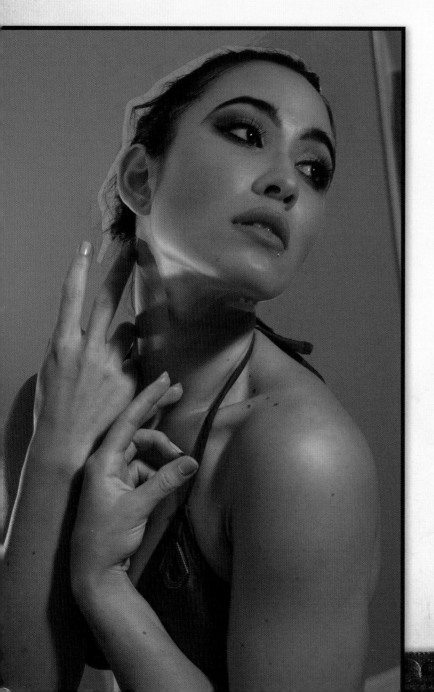

### The Story
"As the sun broke over the horizon, the maiden of the forest could feel its warmth upon her face. The leaves on her body began to tingle as they soaked in the first rays of light in the morning ..."

### The Pose
For this image I wanted to create a female Ent character. Most of the time in fantasy depictions, tree people tend to look like old men, and I thought it would be fun to show one as a sensual female. I combined two different images because one had an interesting position for the hands and the second had a fantastic facial expression.

**Preferred Head Reference**

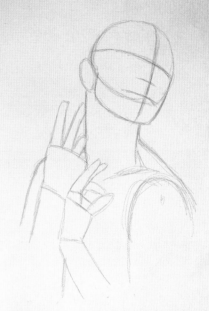

**1** ## Block In the Shapes
Block in the basic shapes for the head and shoulders. Indicate the centerline and guides for the eyes, nose and mouth.

**2** ## Block In the Hands
Block in the hands with simple shapes.

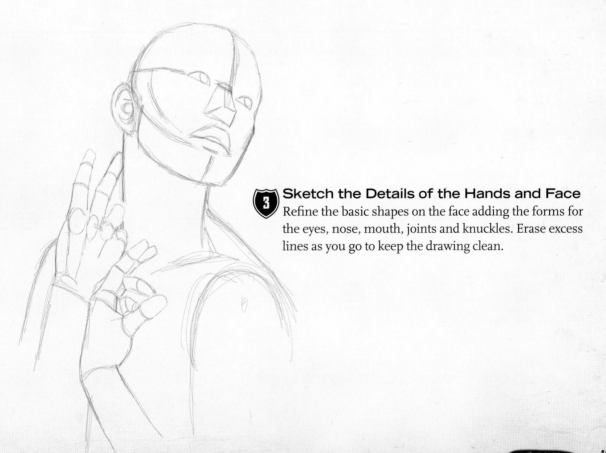

**3** ## Sketch the Details of the Hands and Face
Refine the basic shapes on the face adding the forms for the eyes, nose, mouth, joints and knuckles. Erase excess lines as you go to keep the drawing clean.

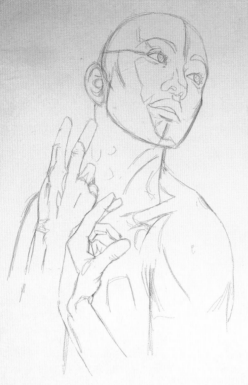

### 4 Refine the Face and Hands
Refer closely to the reference and add more details to the face and hands. Indicate the shadow line on the right cheek and the right side of the neck.

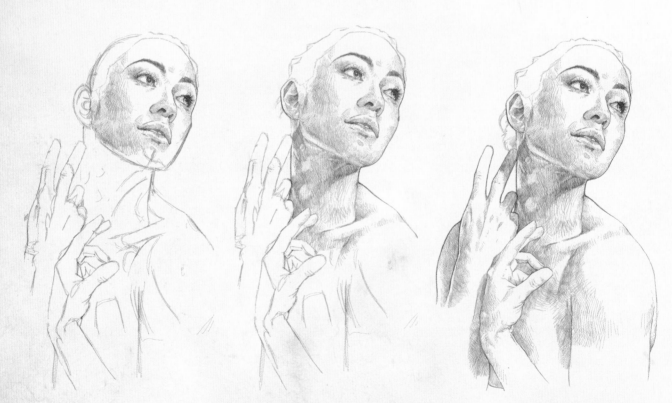

### 5 Shade the Face, Neck, Shoulders and Hands
Lightly shade the face starting with the eyes and working down the neck and body. Keep the shading very light since we will be adding more natural details in later steps.

Visit impact-books.com/fantasyreference to download a free bonus art gallery

**Nature Reference**
Finding nature references can be as simple as walking into the backyard with a camera and some inspiration. Explore multiple points of view and perspectives of each subject your photograph. You don't want to feel stuck wishing you'd snapped the perfect angle after you hadn't.

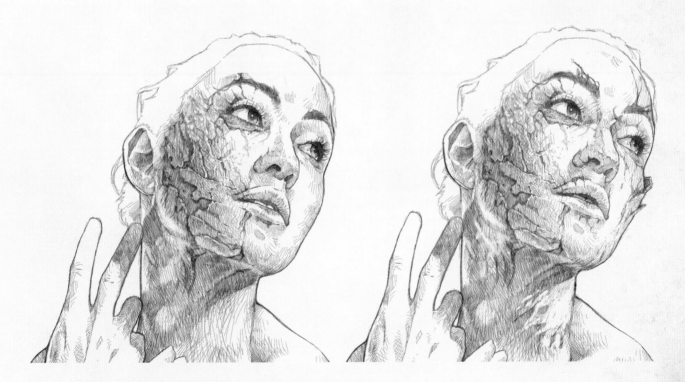

**6 Add Bark Details to the Face and Neck**
Follow the basic contour lines on the face to sketch in bark details. When shading in the bark, make sure to vary the values so the bark doesn't look too flat.

107

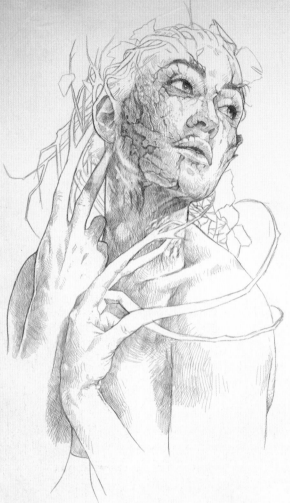

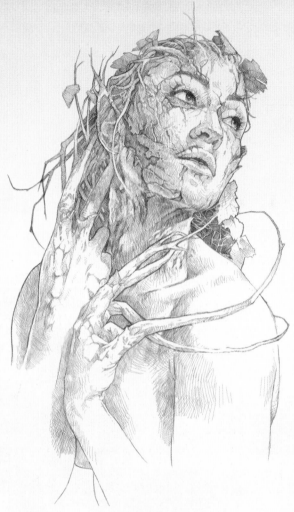

**7** **Block In Branches for the Fingers**
Block in the basic shapes for the elongated fingers, curving the shapes like branches. Block in the vine shapes for the hair. As with the bark, follow the form of the hair to help decide where to put the vines.

**8** **Shade the Hands and Fingers**
Using both of your tree references, add another layer of details, shadows and highlights to the hair, hands, face and branch fingers.

**9** **Finishing Touches**
Push some of the contrasts in values to define the different elements such as the fingers, ears and neck. Also add elements to make it your own such as more leaves, flowers and berries to her fingers and hair.

Visit impact-books.com/fantasyreference to download a free bonus art gallery

## COMBINING MULTIPLE FIGURES IN A SCENE

# AN AMAZON & HER HENCHMAN

As artists, we like to draw the entire picture. We want to show our main characters from head to toe in full detail. It's easy to become overly attached to detailed areas and forget about the composition as a whole. To draw multiple characters, it's important to become comfortable with overlapping areas to create depth and make it appear that your characters share the scene. In real life, subjects almost never line up just right. So when we see it in drawing, it often looks unnatural. Overlapping elements help add a level of believability to fantasy images.

One thing to keep in mind when overlapping an object is to make sure the object in the foreground is either lighter or darker than the object in the background. If the foreground and background are too close in value it will be difficult to see the main subject. Often times when the main subject blends into the background, artists refer this to this as a figure-ground issue.

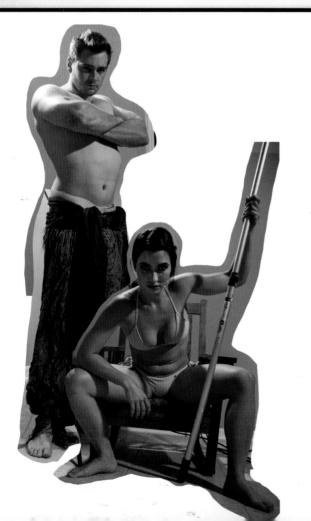

**The Story**
"The blackened jungle is not a place for the lighthearted. After years of blood and sweat, Essa and her henchman carved out a small sanctuary in this dangerous land. This was her home now and no one would ever take it from her as long as she still breathed ..."

**Combined Pose**
This reference is made up of multiple shots. For the Amazon girl I combined two different images with similar lighting, one with the desired pose and one with the head angled toward the viewer. The henchman was photographed at a different time and without the female model, so I made sure that the angle and lighting were as close to the other two images as possible.

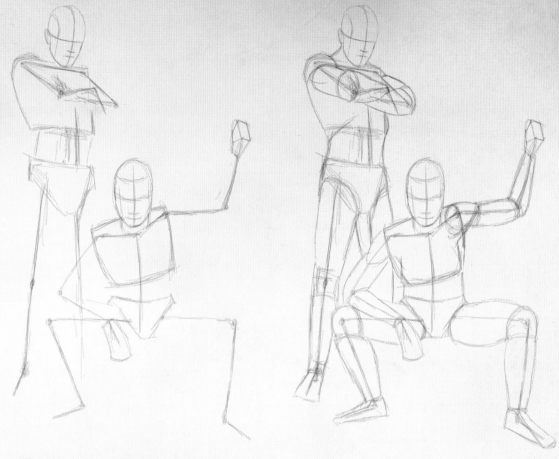

### 1 Block In the Basic Forms

Start with the basic stick figures of both characters. The henchman should be standing slightly higher behind the sitting girl to help push him into the background. As you sketch, erase your guidelines so that it's clear where the figures overlap.

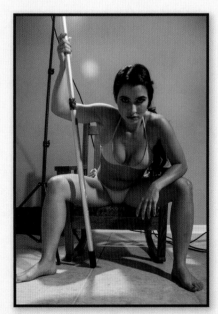

**Amazon Face**

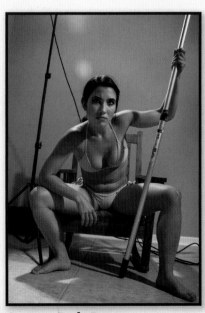

**Amazon Body Pose**

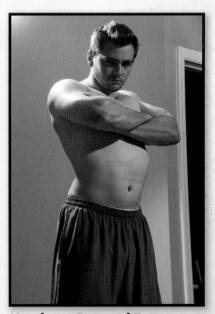

**Henchman Pose and Face**

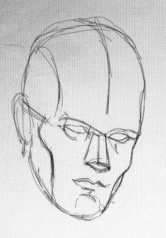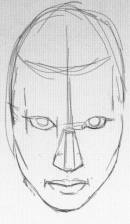

## ② Block In the Facial Details
Block in the simple forms of both characters' faces over the guidelines including the eyes, noses and mouths.

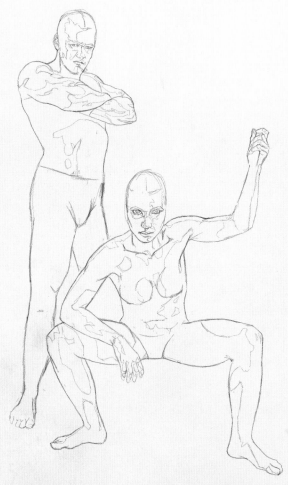

## ③ Refine the Body Shapes
Remove most of the guidelines to refine the body shapes.

## ④ Block In the Shadow Areas
Looking closely at the reference, refine the details on both faces and block in the shapes of shadows and highlights.

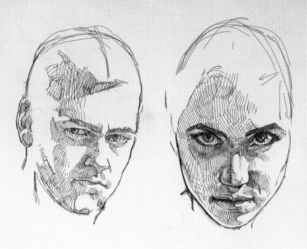

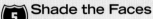

## Shade the Faces

**5** Begin shading the faces. Make sure the girl's features are just a bit darker than his to make her the focus of the final drawing and bring her into the foreground.

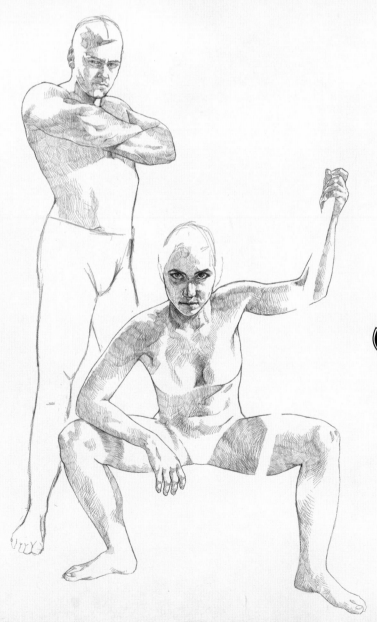

## Shade the Bodies

**6** Add the shading to the torsos, legs and arms. Try not to get too dark at this stage or it will be difficult to erase and add the costuming later. The shadow on her right bicep will help push her forward from the henchman's leg. Also erase the area that will become her spear.

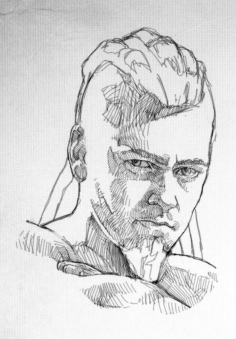

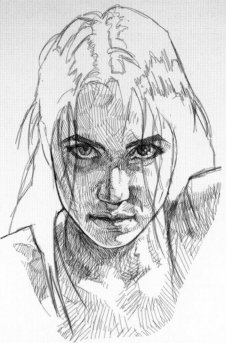

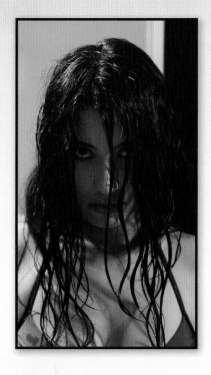

###  Block In the Hair
Block in the basic shapes for the hair. For the girl I used a separate reference to depict some of her hair falling over her face for a more barbaric look.

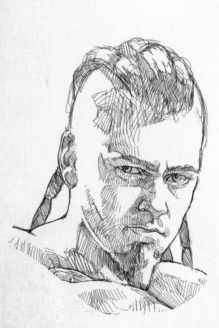

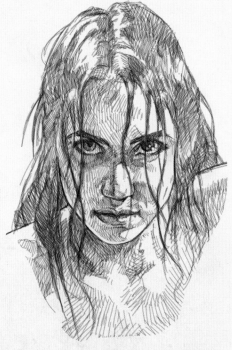

### Shade in the Hair
Shade in the hair and, like the shading of the face, make her hair just a bit darker than his.

Visit impact-books.com/fantasyreference to download a free bonus art gallery

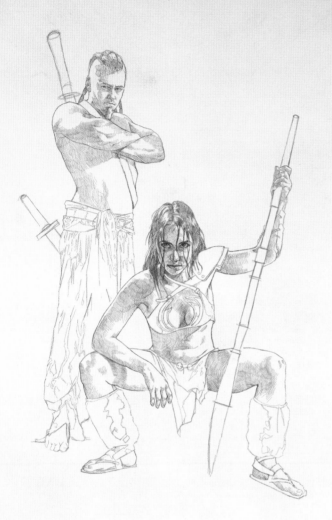

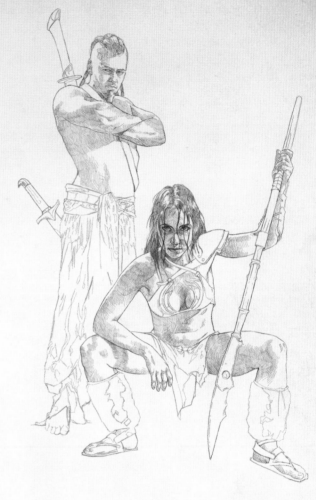

**Blade and Handle Reference**

### 9 Block In and Shade the Clothing and Weapons

Block in the basic shapes for the costumes and weaponry starting with the basic shapes, then slowly adding details. Since she is an Amazon in a jungle environment, her clothing should have a bit of a tribal feel.

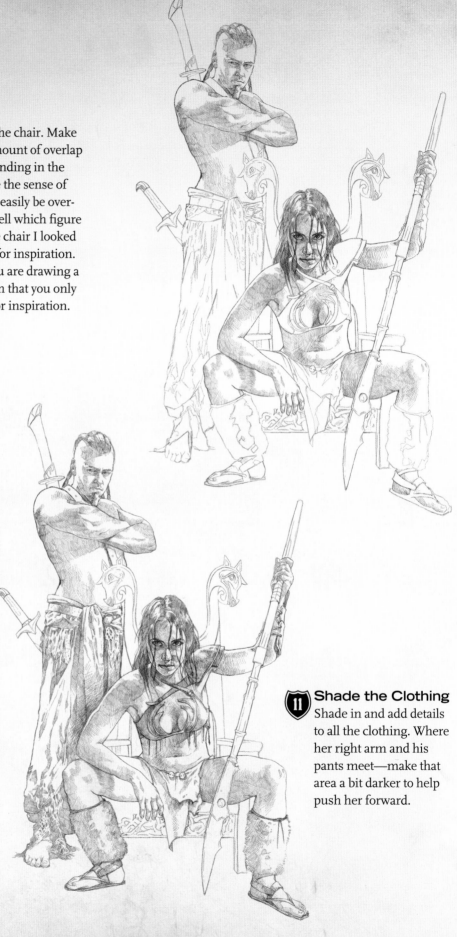

### 10 Block In the Chair

Block in the basic shape of the chair. Make sure to have a significant amount of overlap with the chair and figure standing in the back. This helps to reinforce the sense of depth. Too little overlap can easily be overlooked and make it hard to tell which figure is in the foreground. For the chair I looked at Viking ships and totems for inspiration. Remember, just because you are drawing a throne or chair doesn't mean that you only look at thrones and chairs for inspiration.

### 11 Shade the Clothing

Shade in and add details to all the clothing. Where her right arm and his pants meet—make that area a bit darker to help push her forward.

 **Shade the Chair**
Shade in the chair adding darker values to the area of the chair that overlaps his stomach. This will help him appear to stand behind the chair.

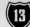 **Shade the Weapons**
Shade in the weapons keeping the spearhead darker than the shadows on her leg so they don't blend in together.

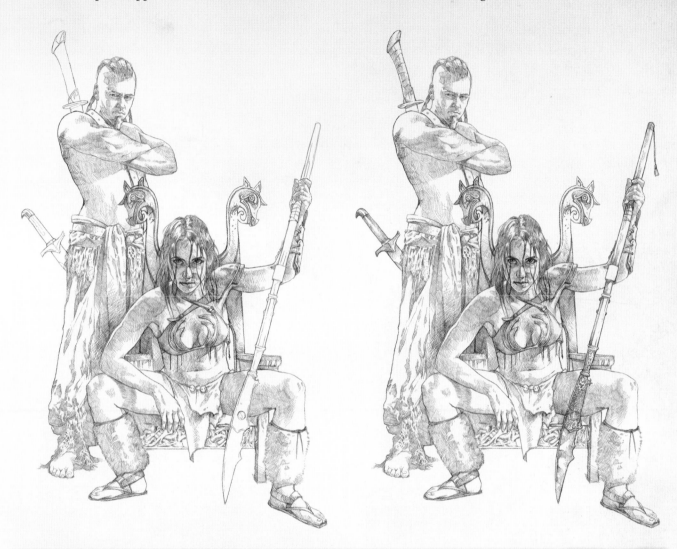

## THE ARTIST'S JOURNEY

As artists, we tend to get caught up comparing ourselves and our successes to those of our colleagues and friends. But it is important to keep in mind that creating art is a personal and individual experience. It really doesn't matter how old or young you were when you fell in love with drawing. Some artists don't reach their stride until they are in their fifties, while others find it when they are still in their twenties. There is no finish line to becoming an artist. It's all about the journey of finding that new thing to help us learn or improve our work. Each time you climb a metaphorical mountain in art and look across the horizon, you find yourself looking at another mountain to climb. In other words, each time you find you have reached a goal with one aspect of your art, you will look at your work again and find something else you want to get better at. Looking at others' work to find areas you can improve in your own work is fine, but doing so should stimulate thought and exploration, not demoralize your passion.

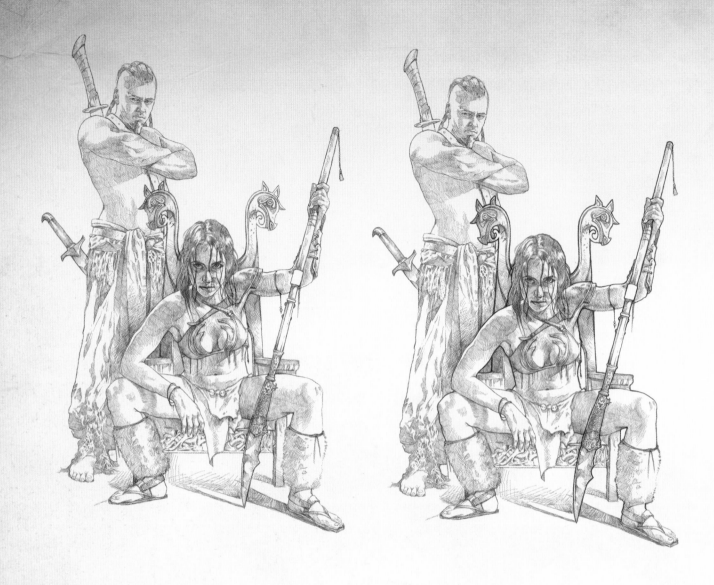

 **Add Ornamental Details**
Draw in some extra details to enhance your characters' personalities. Add the shadowing on the floor and details to the costuming like bracelets on the wrist and an armband.

 **Outline the Edges**
Adding a darker edge to the chair and foreground figure will help them pop out even more. Just make sure when adding that darker edge that it isn't too distracting.

 **Finishing Touches**
Stand back and take a critical look at the overall image. Make sure to darken the bodyguard's legs if they blend too much with her arm. Consider ways to make this your own such as bone jewelry, tribal tattoos or armor on the bodyguard.

Visit impact-books.com/fantasyreference to download a free bonus art gallery

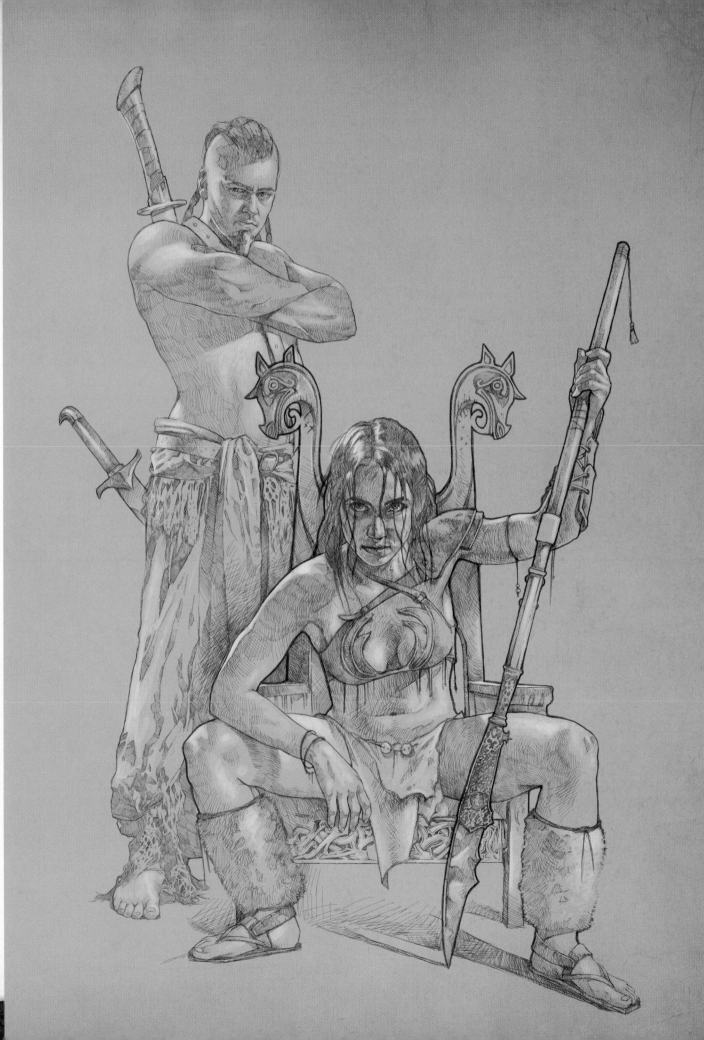

# CREATING A BATTLE SCENE
# FAIRY APOCALYPSE

It would be perfect if you could hire seven or eight models to create one reference to draw from. Unfortunately this rarely goes well. Shooting more than two models in one image can be extremely difficult. Little things like a model blinking, a hand covering the face, or a prop making an odd tangent off a shoulder can ruin a shot. Adding three or four more models can make it nearly impossible to get a good image. A much more efficient approach for a strong scene with multiple characters is to use no more than two models and then assemble your main reference digitally. For this scene, I used three different models over four different sessions.

### The Story
"... the epic battle raged on with demons clawing their way up from the underworld. The fairies were so tangled with the demons, it was impossible to tell where one form ended and the other began ..."

### The Pose
When creating complex scenes with more than one or two characters, avoid as many tangents as possible. A tangent is when two or more elements come together in an awkward way such as when an outside line or edge of one object lines up with the outside line or edge of another object forcing them to use a common line. For example, an odd tangent to avoid would be if the edge of an arm were to line up with the edge of another character's leg.

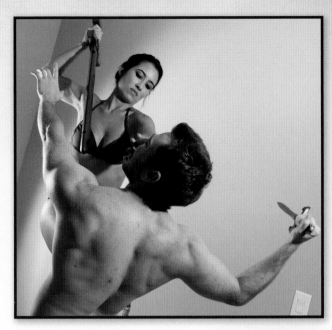

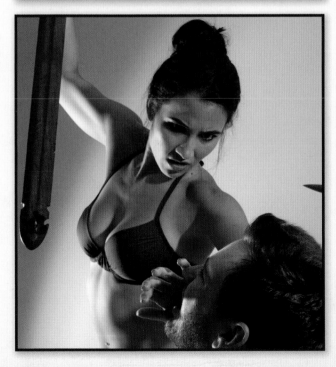
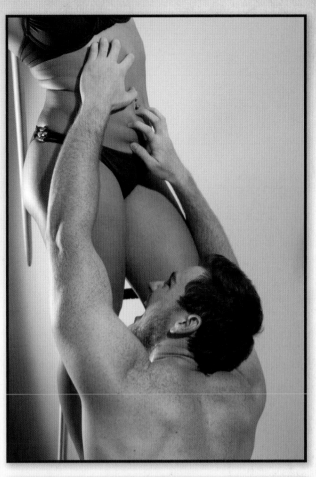
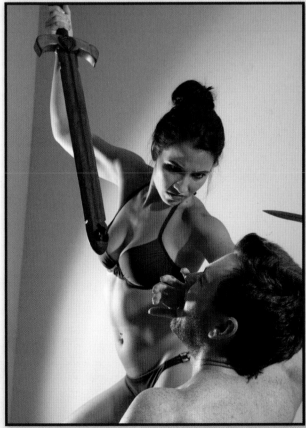

## Sketch the Stick Forms

Start with the basic stick forms. Since this image contains seven figures—four fairies and three demons—there is a lot of overlapping, so be sure to take your time on this step. Although simple lines are easy to draw, this step is still the foundation for the entire drawing.

## Block In the Figures

Begin adding the geometric forms for the figures. This is where tangents will become noticeable. You will still have a few tangents, just try to eliminate the worst of them. One of the tangents that was difficult to remove here was where the top fairy's bent leg lines up with the demon's arm.

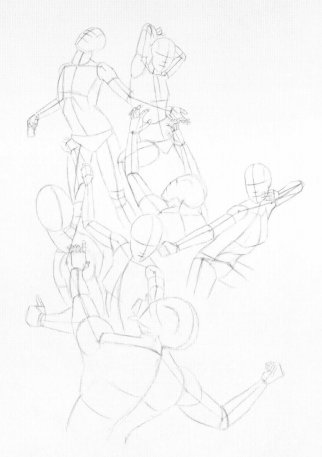

## THE BIGGER THE DRAWING, THE BETTER

You should always draw as large as possible. Large drawings are much easier to do and almost always more successful even if they are more time consuming. If you are creating a drawing of a face and it is drawn an inch (2.5cm) tall, and you are off by a quarter inch (6mm) with where you place the nose, chances are it will look very bad. If you draw that same face, but it's 18 inches (46cm) tall, that quarter inch (6mm) is not so significant. Professional comic artists and book cover illustrators generally work a minimum of 150% larger than the final size that their art will be printed. They do this because when the art is reduced down, details become much crisper. In fact, many book cover illustrators do not paint a face smaller than one inch (3cm), and some never paint faces smaller than three inches (8cm).

**3** **Add the Face Shapes**
Add the basic shapes for the six visible faces.

**4** **Refine the Face Details**
Add slight exaggerations to the fairies' expressions, such as dramatic wrinkles on the foreheads and around the eyes, to create tension in the scene.

**5** **Shade the Faces**
Shade in all of the faces continuing to add tension to the fairies' expressions.

## 6 Sketch the Shadow Guidelines
Draw in the basic shapes for the body forms and add guidelines for the shadows.

## 7 Shade the Body Forms
Lightly shade in the figures leaving areas where clothing can be added later.

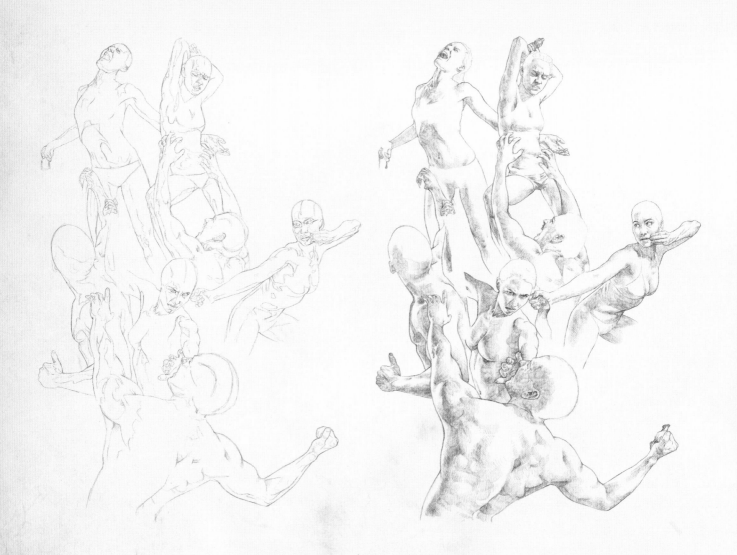

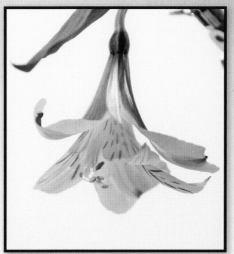

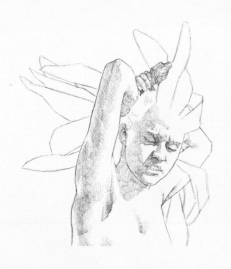
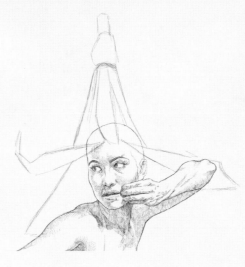
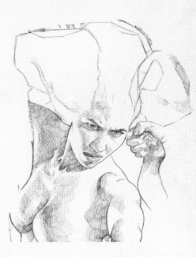

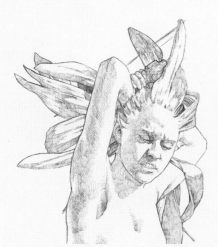
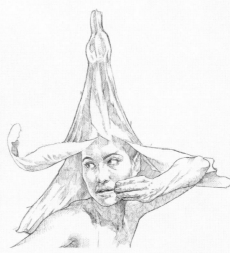
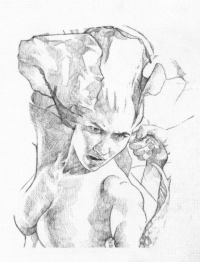

### 8 Block In and Shade the Flower Hair

Block in the flowers on the fairies' heads using unique references for each. Gently shade in the flowers creating a smooth transition from skin to petals.

## 9 Block In and Shade the Horns

Block in the basic shapes for the horns. They are loosely based on gnarly tree branches but mostly from imagination, so have fun with the forms. Make sure the lighting stays consistent when adding the shadows.

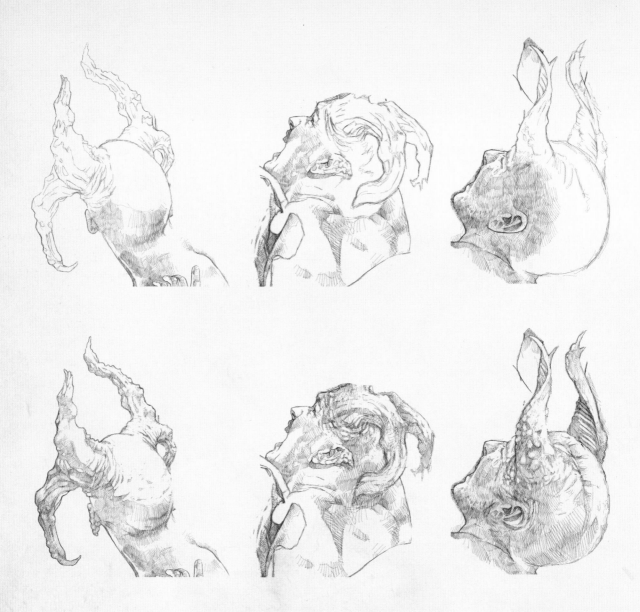

Visit impact-books.com/fantasyreference to download a free bonus art gallery

 ### Block In the Wings
Block in the basic shapes for the fairies' wings using some sort of insect wing reference. Make sure to indicate the larger veins, but don't get too detailed until all of the larger shapes are in place.

### Add Details to the Wings
Add details to the wings. Keep the outside edges a bit darker to help hold the overall wing shape together.

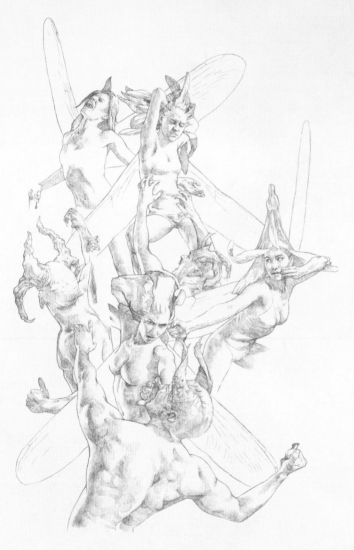

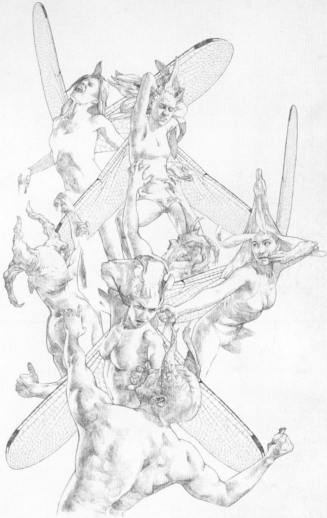

### Wing Reference
Sometimes it's not always possible to use your own reference for everything. In this case I wanted to use a dragonfly wing for the main reference for the wings though I had no clear, detailed image of my own. I chose an image from the Internet and created a detailed drawing study of the wing to use as a reference. I was able to make the image my own by not copying the original too closely.

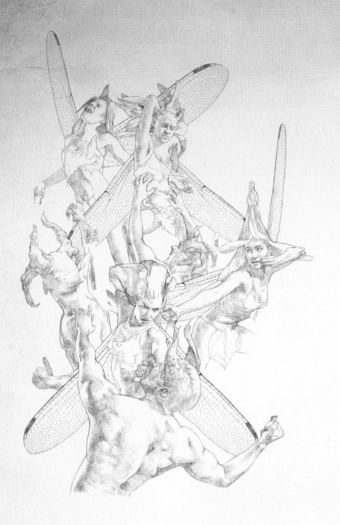

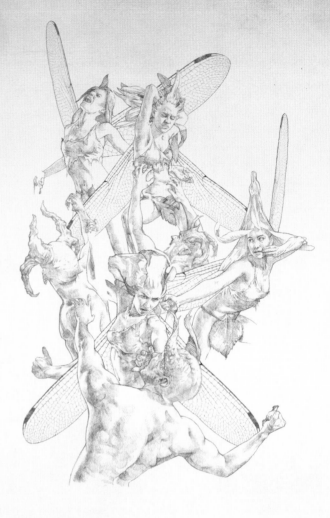

## 12 Block In the Clothing
Block in the basic shapes for the clothing using leaf references for the fairy costumes.

## 13 Shade the Clothing
Shade in the clothing allowing some of the edges to become blended into the shadow areas.

**Leaf Reference**

Visit impact-books.com/fantasyreference to download a free bonus art gallery

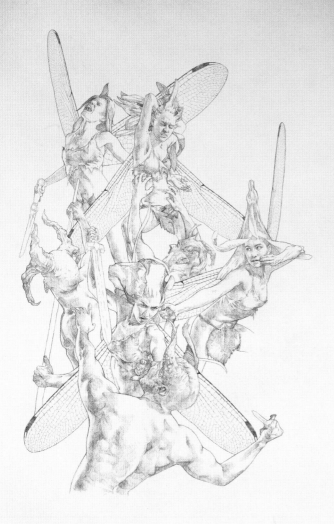

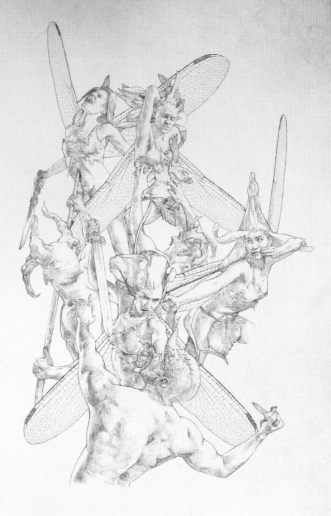

**14 Block In the Weapons**

Block in the shapes for the weapons so they lead the eye around the composition as a whole, almost like arrows pointing where the viewer should look.

**15 Shade the Weapons**

Shade in the weapons keeping the details simple so the image doesn't get too complex.

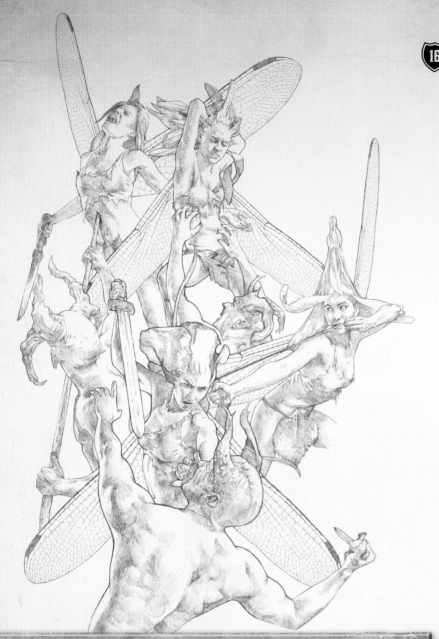

**16** **Finishing Touches**
Finish the image by defining the edges of some of the foreground elements. Try not to get carried away and add too many edges. That might make the image look pasted together.

## LOOK BEYOND THE PHOTO

The goal of a reference picture is to help the artist to see form, position and light. In fantasy art it's critical that you explore beyond the reference, transforming the image to fit your fantasy world vision. A simple reference of a woman can become an elf, a young man can become an old dwarf, or a heavily treed park can become an eerie forest. The possibilities are only limited by our imaginations ... as long as we can see beyond the photo!

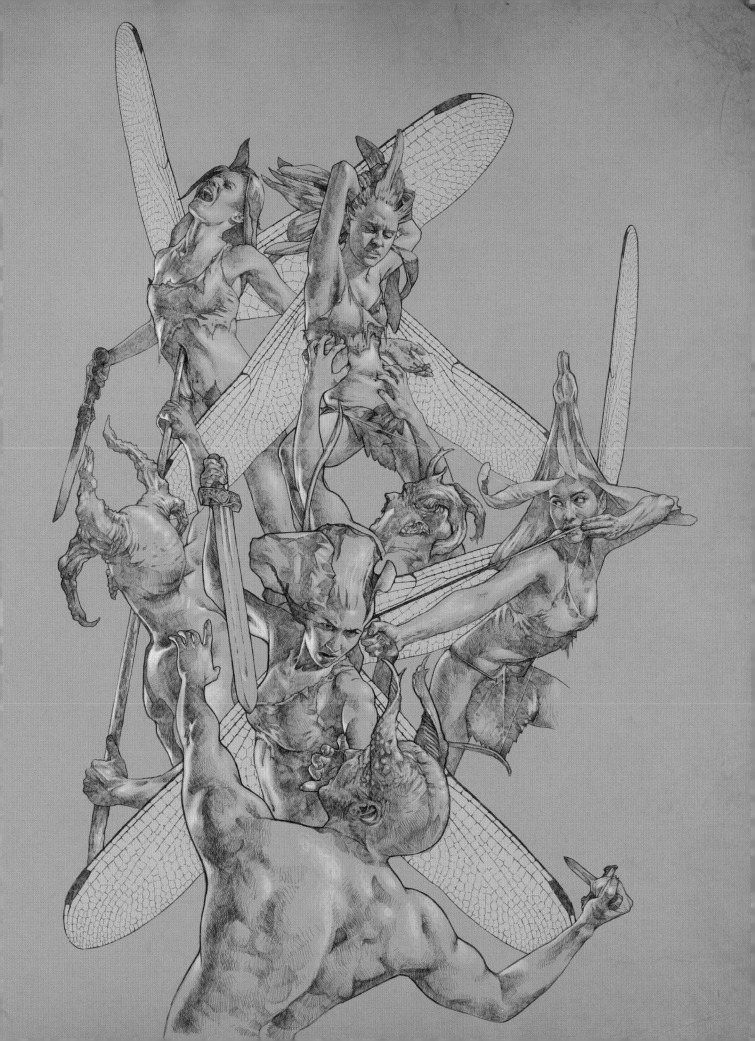

# GALLERY

The following gallery includes a few of my paintings and the references I used to create them. This section will give you some insight into my process of integrating photo references into my work. As you look at the references, remember that reference photographs are not meant to be great (or even good) images in terms of classic photography. Their goal is to give you all the information you need to create a beautiful drawing or painting.

JOAN OF ARC © John Stanko

## Joan of Arc

This was a painting I started a few years back at the Illustration Master Class and I continued to work on it over two years after the class. Thankfully it worked out great for the cover of this book. This painting required multiple shoots with various models over that two year period.

132

  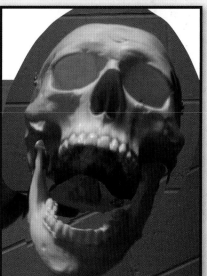

## Tenacious Deed

This painting was created for *Magic the Gathering* in set M14. The art order was to show a skeleton emerging from a dark hole in a dungeon. Having the right reference can make all the difference sometimes. In this piece, access to a full skeleton as a reference was essential to make it work.

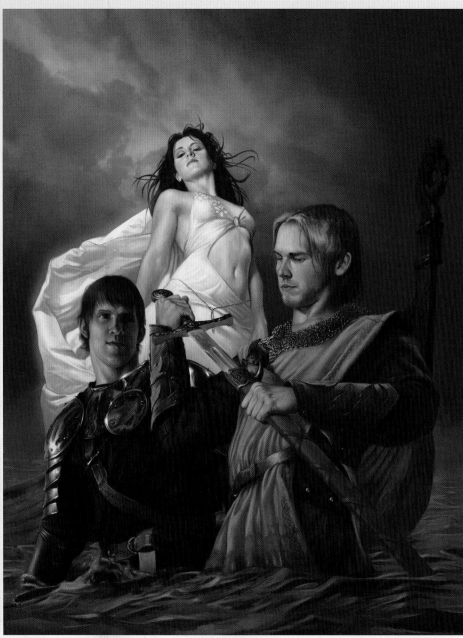

## Orion and King Arthur

This is a cover painting created for Ben Bova's *Orion and King Arthur*. It depicts Arthur receiving Excalibur from the lady of the lake with his friend Orion looking on. It's good to always have a camera close by. If you see something interesting, try to get a picture of it even if you are not sure how you will use it. I photographed the clouds two years before I painted this.

## Outland

This was a book cover for G.J. Koch's *Alexander Outland: Space Pirate*. This was a fun book, which made the cover a lot of fun to work on. An interesting detail about this piece, I used an outtake reference from the *Orion and King Arthur* shoot for the figure on the upperleft. That's why it's helpful to keep all of the shots you take in a photo shoot. Sometimes you get lucky and already have a great reference ready to go.

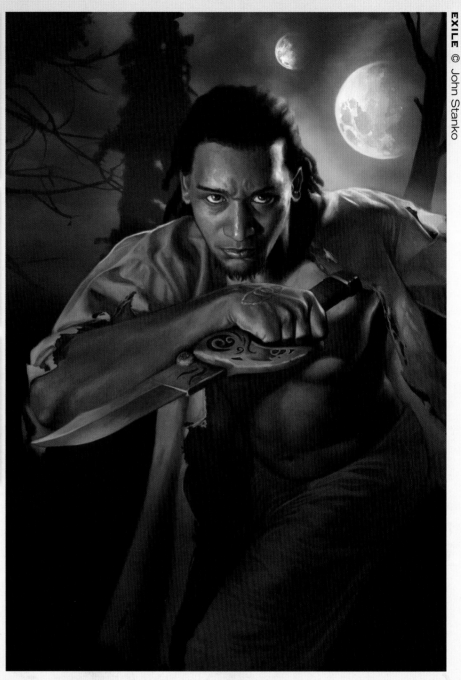

## Exile

This was a book cover for Betsy Dornbusch's *Exile*. This model was a wonderful gentleman that I met at the gym, and although it was his first time in front of the camera he did a fantastic job. Proof that you never know when or where you will run across someone that has the perfect look for a painting or drawing.

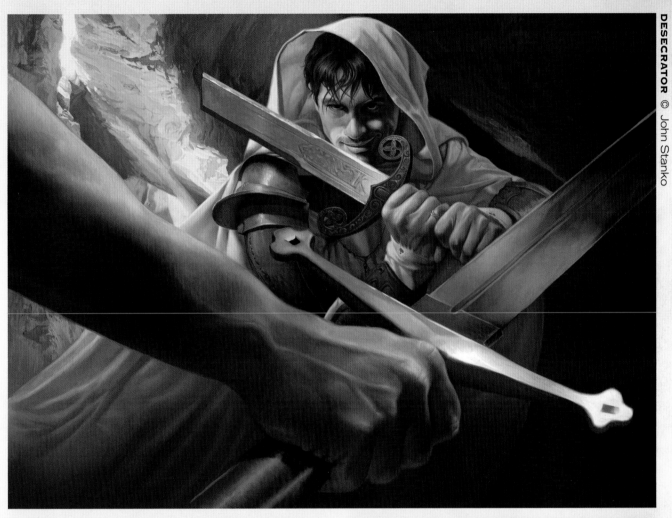

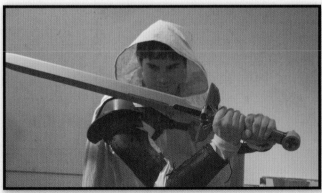

## Desecrator

This was a cover for Steven Brust's short story *The Desecrator*. For this image I altered the lighting on his face to be more dramatic. Just because the lighting looks a certain way in the photo doesn't mean you have to draw or paint it that way if changing it can make the final piece look better.

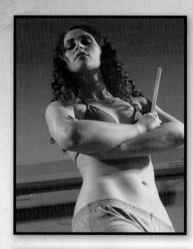

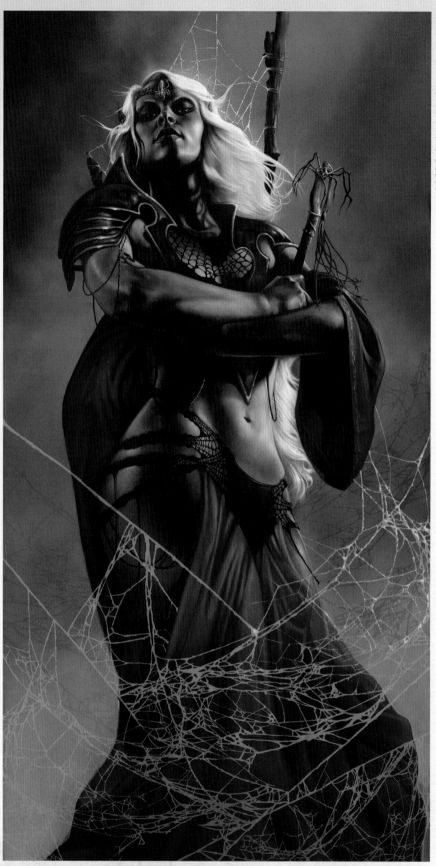

## Lolth

This is Lolth the Spider Queen used in *Dungeons & Dragons 4E Monster Manual 3*. Although Lolth is only five feet tall, she is the evil goddess of the dark elves. To make a five-foot woman look powerful I used a low-angle point of view so that she is looking down on the viewer. When it comes to storytelling, remember something as simple as the point of view can be a useful tool.

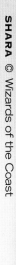

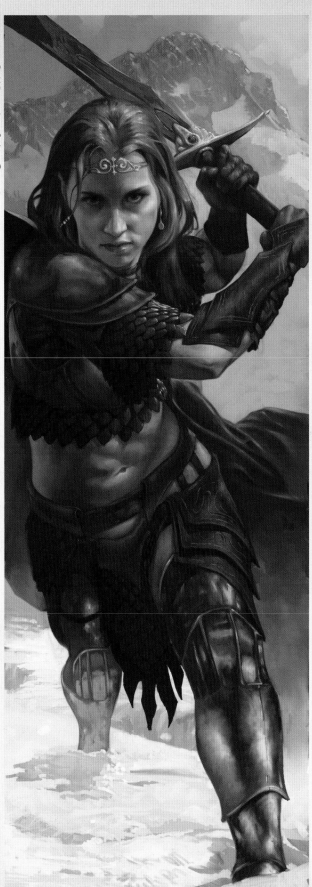

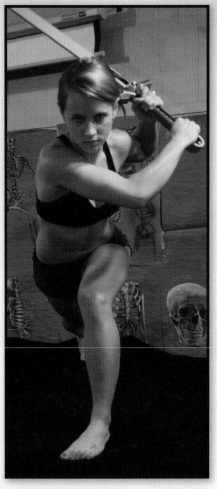

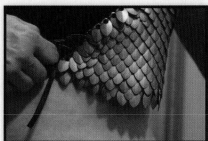

## Shara

This is a painting of the character Shara for the book *Heroes of the Fallen Lands*. Although this appears to be a simple pose, it took four different shoots with three different models until I finally got what I had in my head. If there is a look and feel that you really want and just can't seem to make it work during a shoot, don't be afraid to try a different model.

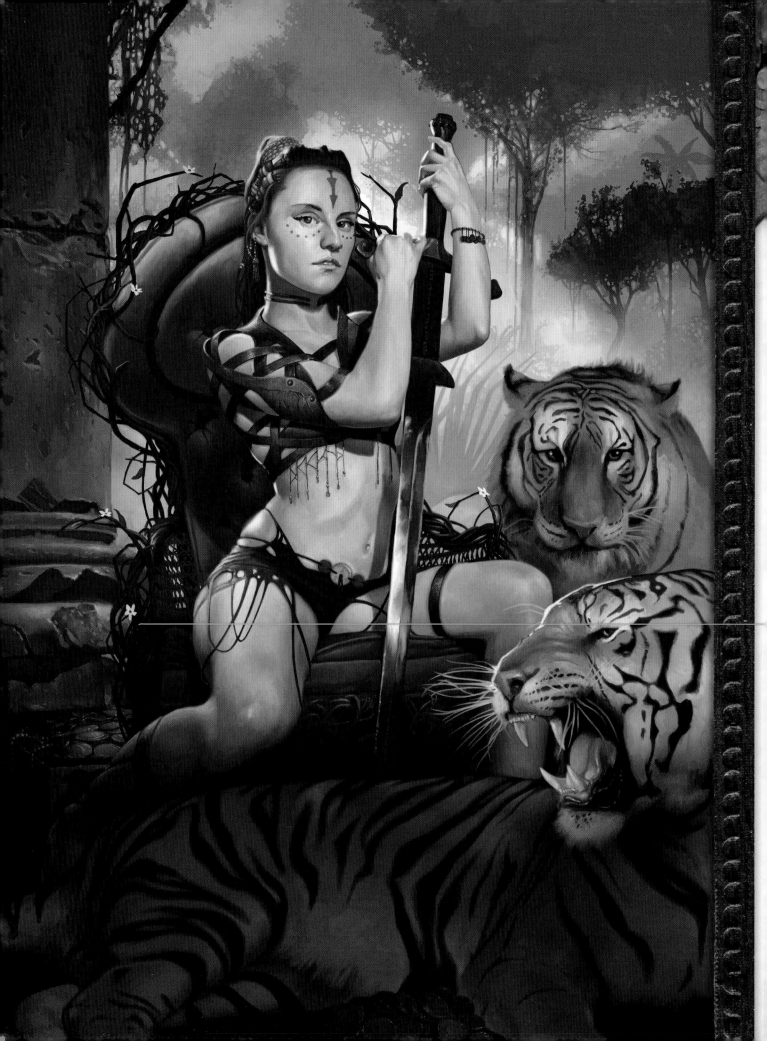

# NOW IT'S
# YOUR TURN!

This book is just the beginning of your journey into drawing dynamic characters. Now it's your turn to start gathering some references and putting your imagination down onto paper. Remember there is no wrong way to work with references. Everything from gridding to freehand to tracing are all valid, you just need to find which process works for you. The only way to do that is to try each and see which one yields the best results for you.

If you are new to fantasy art and using reference, hopefully this book has inspired you to try to shoot some of your own reference photos. For the more seasoned artists, I hope that you might have learned a trick or two. Above all things, remember that a reference is just a reference! Don't be a slave to it! Don't mindlessly copy the picture! Use the reference to help show you what to draw and how to draw it.

Thank you for joining me on this exploration of how to create dynamic fantasy characters by using photo references. For myself, writing this book has given me a chance to look at my own process in a critical way. As a fantasy illustrator, tight deadlines can make it easy to fall into habits of mindlessly following the same process for every image. Writing this book has been a wonderful reminder of the many different strategies for creating images. I know writing it has made be a better artist and I hope reading it has made you better as well.

Now ... go make stuff!

# INDEX

# • DEDICATION •

To my wife Kristie, whose support and understanding has made it possible for me to follow my dreams and actually make a living painting barbarians and princesses. And to my son John, who makes it all worthwhile.

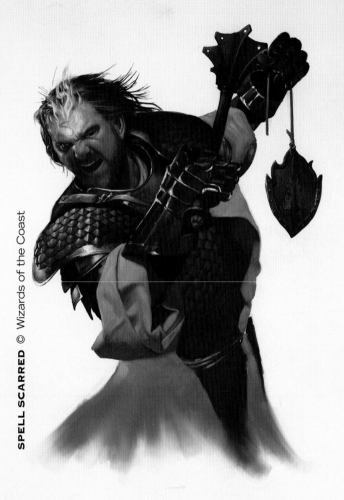

SPELL SCARRED © Wizards of the Coast

# • ABOUT THE AUTHOR •

John Stanko earned his Master of Fine Arts from Virginia Commonwealth in 2005, and is an assistant professor of graphic design at the University of South Florida Saint Petersburg with over fifteen years of teaching experience. He has created hundreds of illustrations for the gaming industry. Some of his projects include Sony Entertainment's *Legends of Norrath*, Hasbro's *Magic the Gathering*, *Star Wars Galaxies* TCG, *Lord of the Rings* LCG, *Star Wars* LCG, *Dungeons & Dragons 4E* and *World of Warcraft* TCG. His work has been recognized at both Gen-Con and DragonCon and in 2008 he was nominated for a Chesley award. His work was accepted into the prestigious *Spectrum 18, 19, 20: The Best in Contemporary Fantastic Art*. He also created cover art for TOR, ImagineFX and Nightshade Publishing. Visit his website at stankoillustration.com.

# • ACKNOWLEDGMENTS •

First I would like to acknowledge the wonderful faculty at the Illustration Master Class workshop. Dan Dos Santos, who first showed me how to really work with a reference, and Greg Manchess, who taught me not to rely on it too much. To the other faculty, Rebecca Guay, Scott Fischer, Donato Gincola, Boris Vallejo, and Julie Bell, that each taught me more than I could ever list. A special thanks to Todd Lockwood who's advice and constructive critiques have positively impacted my work more than any one person. Finally, I would like to thank the many great art directors that have taken a chance on me, especially Jon Schindehette, Kate Irwin, Mari Kowkolsky, Irene Gallo, Jeremy Jarvis, Jeremy Cranford and Zoe Robinson.

**MASTERING FANTASY ART | DRAWING DYNAMIC CHARACTERS.**

Other fine IMPACT Books are available from your favorite bookstore, art

fw media

supply store or online supplier. Visit our website at fwmedia.com.

18  17  16  15  14   5  4  3  2  1

DISTRIBUTED IN CANADA BY FRASER DIRECT
100 Armstrong Avenue
Georgetown, ON, Canada L7G 5S4
Tel: (905) 877-4411

DISTRIBUTED IN THE U.K. AND EUROPE
BY F&W MEDIA INTERNATIONAL
LTD Brunel House, Forde Close, Newton Abbot, TQ12 4PU, UK
Tel: (+44) 1626 323200, Fax: (+44) 1626 323319
Email: enquiries@fwmedia.com

DISTRIBUTED IN AUSTRALIA BY CAPRICORN LINK
P.O. Box 704, S. Windsor NSW, 2756 Australia
Email: books@capricornlink.com.au
Tel: (02) 4560 1600; Fax: (02) 4577 5288

ISBN 13: 978-1-4403-2958-6

Edited by **Sarah Laichas**
Designed by **Brianna Scharstein**
Production coordinated by **Mark Griffin**

IMAGE PG 2 | LOLTH © Wizards of the Coast
IMAGE PG 3 | MARR © Sony Online Entertainment

## METRIC CONVERSION CHART

| CONVERT | TO | MULTIPLY BY |
|---|---|---|
| Inches | Centimeters | 2.54 |
| Centimeters | Inches | 0.4 |
| Feet | Centimeters | 30.5 |
| Centimeters | Feet | 0.03 |
| Yards | Meters | 0.9 |
| Meters | Yards | 1.1 |

# IDEAS. INSTRUCTION. INSPIRATION.

Download a FREE bonus art gallery at impact-books.com/fantasyreference.

Check out these **IMPACT** titles at impact-books.com!